Light, Space and Time

Uncommon Images of Common Things

By John R. Math

© John R. Math
All Rights Reserved

ISBN 978-0-6151-3763-6

Dedication

This book is dedicated to my Grandmother who gave me my first camera, a 35MM Pentax when I was child. She also gave me an appreciation of art and of travel. Most of all, she encouraged me to express myself and she gave me the love of photography that has been with me throughout my life. I also want to thank everyone who has ever believed in my ability throughout my life.

Thank you Grandma for everything that you did for me and I wish you were here to share this book with me. Grandma, this book is for you.

Acknowledgements

I wish to express special thanks to Melissa, Mick and Dixie Press for all of their help, my friends and my employees, especially Rita who helped me with this book along the way. Also, special thanks to Lisa who always believed in me and gave me the encouragement to proceed with this project. Without her encouragement, I would have never even attempted this book.

Contents:

Foreword	1
Introduction	3
Boardwalk Abstracts	5
Pipe Abstracts	13
Scaffold Abstracts	19
Underground Abstracts	27
Tracks Abstracts	35
About the Author	49

Foreword

We are all amazed by magnificent photographs of mountains, oceans and nature. They are incredible scenes that we seen for years in National Geographic, travel magazines and in numerous coffee table books. These photographs are inspiring to us and somewhere deep inside of us we connect with them. Photographs such as these, allows us to see things and places that most of us can only hope to see one day.

Incredible pictures like these increases our awareness of our Creator and how special our existence is. Sometimes these photos leave us breathless and sometimes we may be confused as to how or why these things were created. Either way, we are usually left in awe of our Creator and how things are. We somehow feel connected to something larger and yet at the same time we also feel small and insignificant. Will we ever understand why? Probably not, but we can still enjoy and admire them and continue to search and seek answers.

In "my search" I photograph everyday places and things but I may look at them in a different manner or from a different angle then most people and most photographers. I photograph these places and

things from an alternate "point-of-view" and I am inspired and in awe of what has been created for us. Though these ordinary things were made by man and they become the focal point and the source of the photograph, they have also been touched by God in their shapes, colors, textures and form. These photographs have not been manipulated with any type of digital software or by any digital filter system or technique. These photographs represent a new way of looking at something in a different manner than we usually do. God has provided us with beauty, form and function, even in areas that we would not normally look. They are there every day for us to discover and enjoy, if we will only look closely.

Introduction

Prior to recording these images, I feel as if I was led to these places or I am inspired to take these pictures in strange places. I am learning to not question these 'feelings' and to just go along. There are times, I feel foolish while I am taking theses photos, as they are not normal pictures, being taken at normal times and in a conventional manner. Sometimes people will stare at me while I am taking the photos and wonder what the heck I am doing. When finished with a session, I cannot wait to transfer the images from my camera into my computer. It is then that I discover and see what will be revealed and what has been hidden from view. It is then that I start discovering the strange lights, colors and shapes in each frame. I know that I did not create or produce these images, I have simply discovered and recorded them! I am honored that I have been chosen to produce these images and through this book I share them with you.

From this book and the images inside, I hope that you are also inspired to start on your search for the incredible beauty that God provides for us every

day in so many different ways and places. They are usually places where we not normally would look.

This book is not for commercial purposes. Any income, derived from this book, after any publishing expenses will be donated to worthy causes, individuals or situations that are deserving. Any suggestions to this end will be considered by me and my staff.

Thank you.
John R. Math

Boardwalk Abstracts

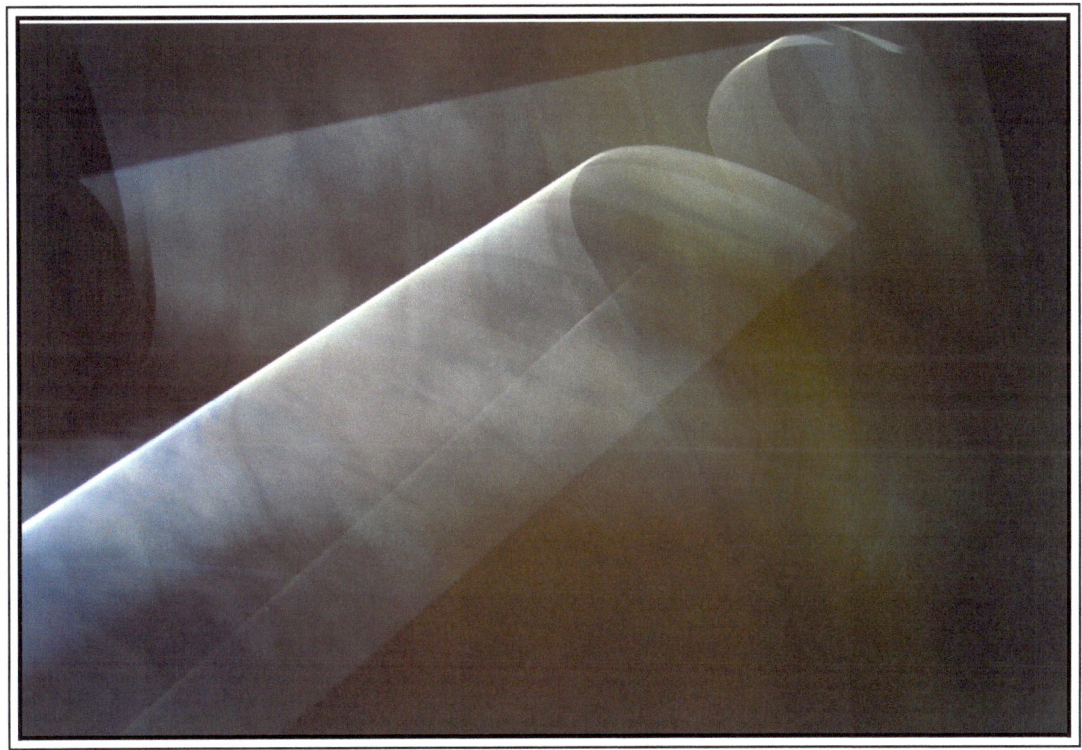

These shots are taken from beneath a boardwalk at the beach. They are snippets of light that finds it way between the boards and braces. Depending on the angle and the exposure, I receive and record the shapes and colors. I find the whole process so intriguing. I am always amazed at the outcome and I continue to look at the photographs over and over again and I find different things that I missed previously. I simply cannot take any credit for these images.

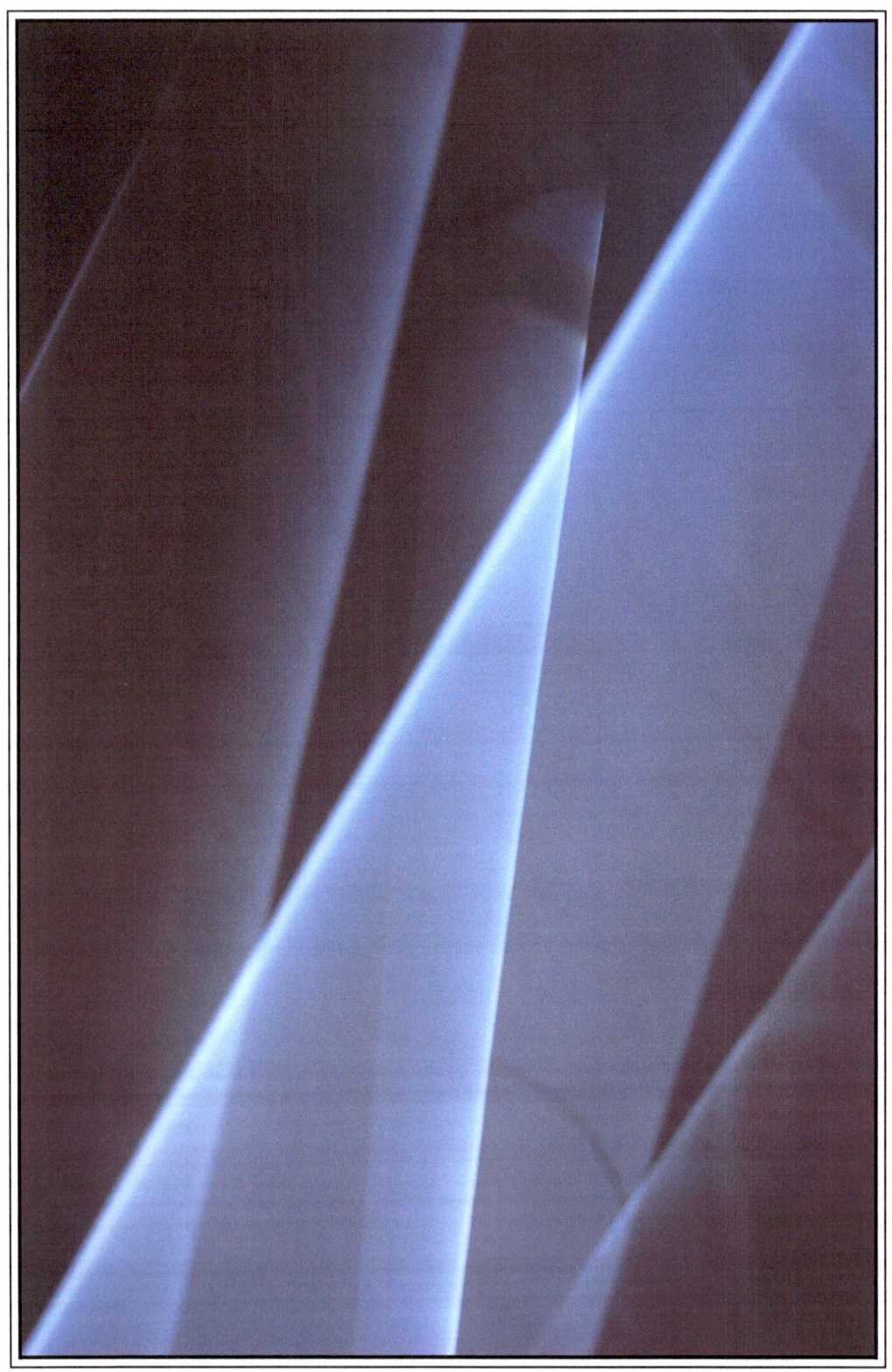

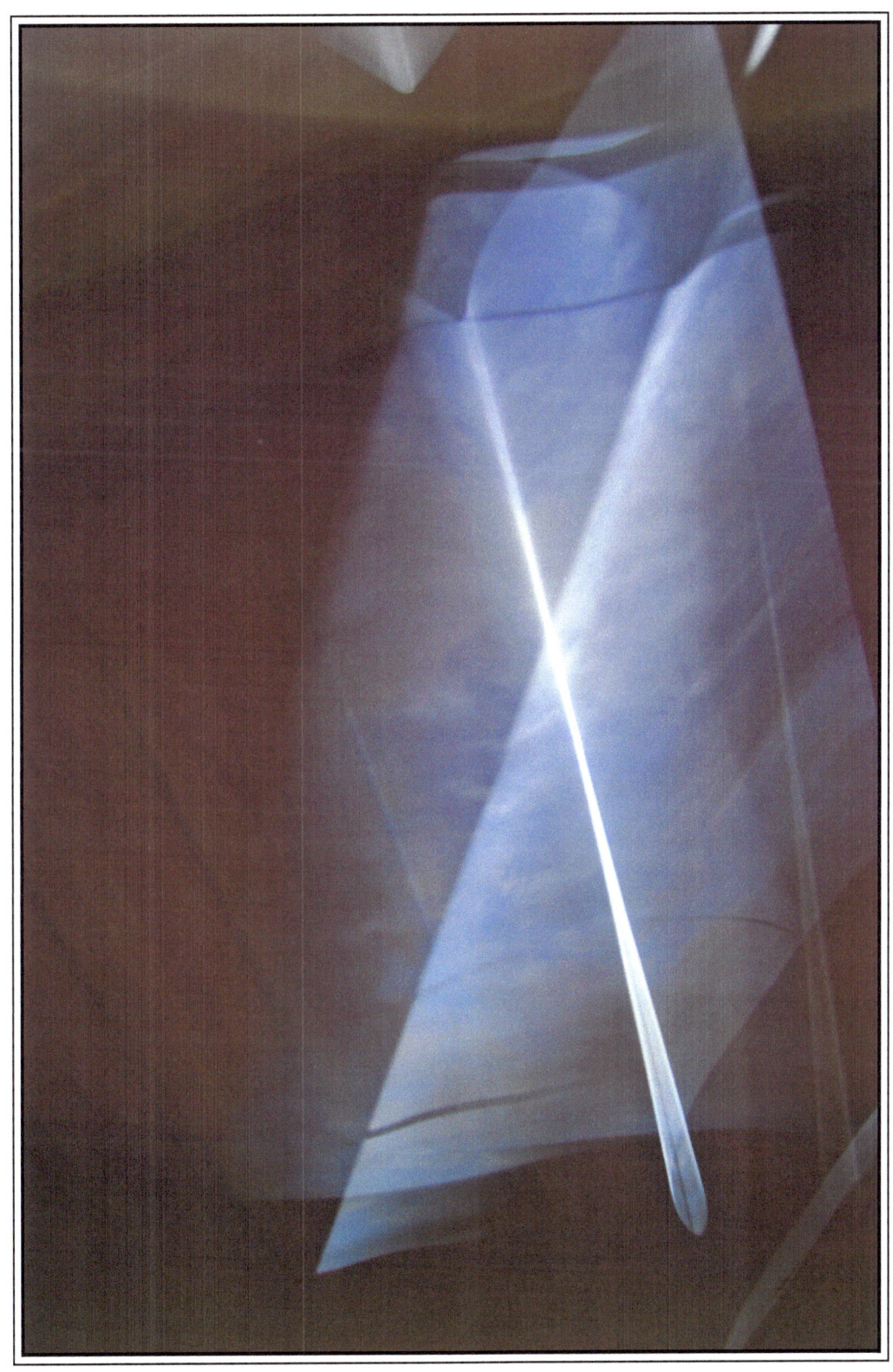

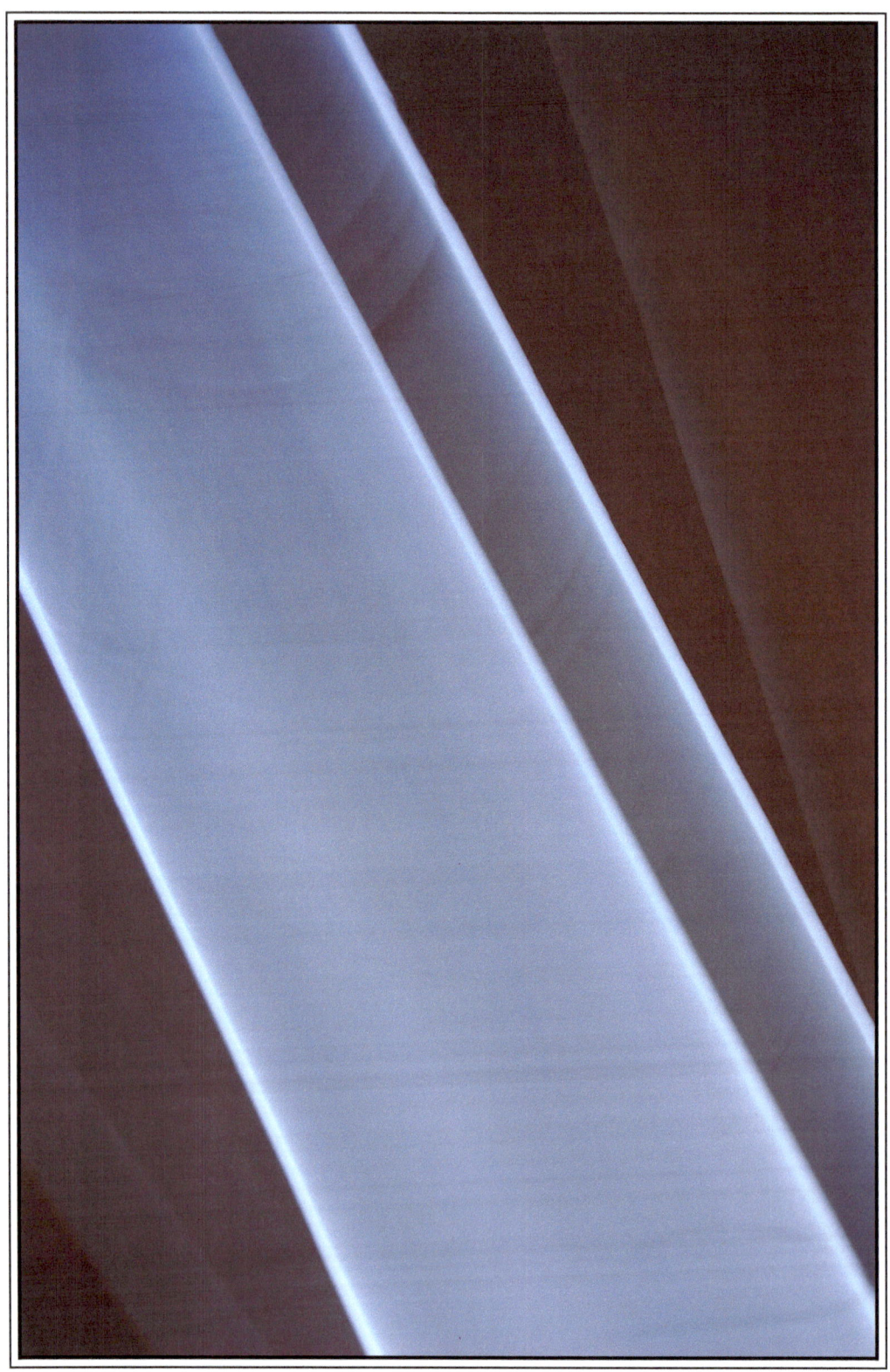

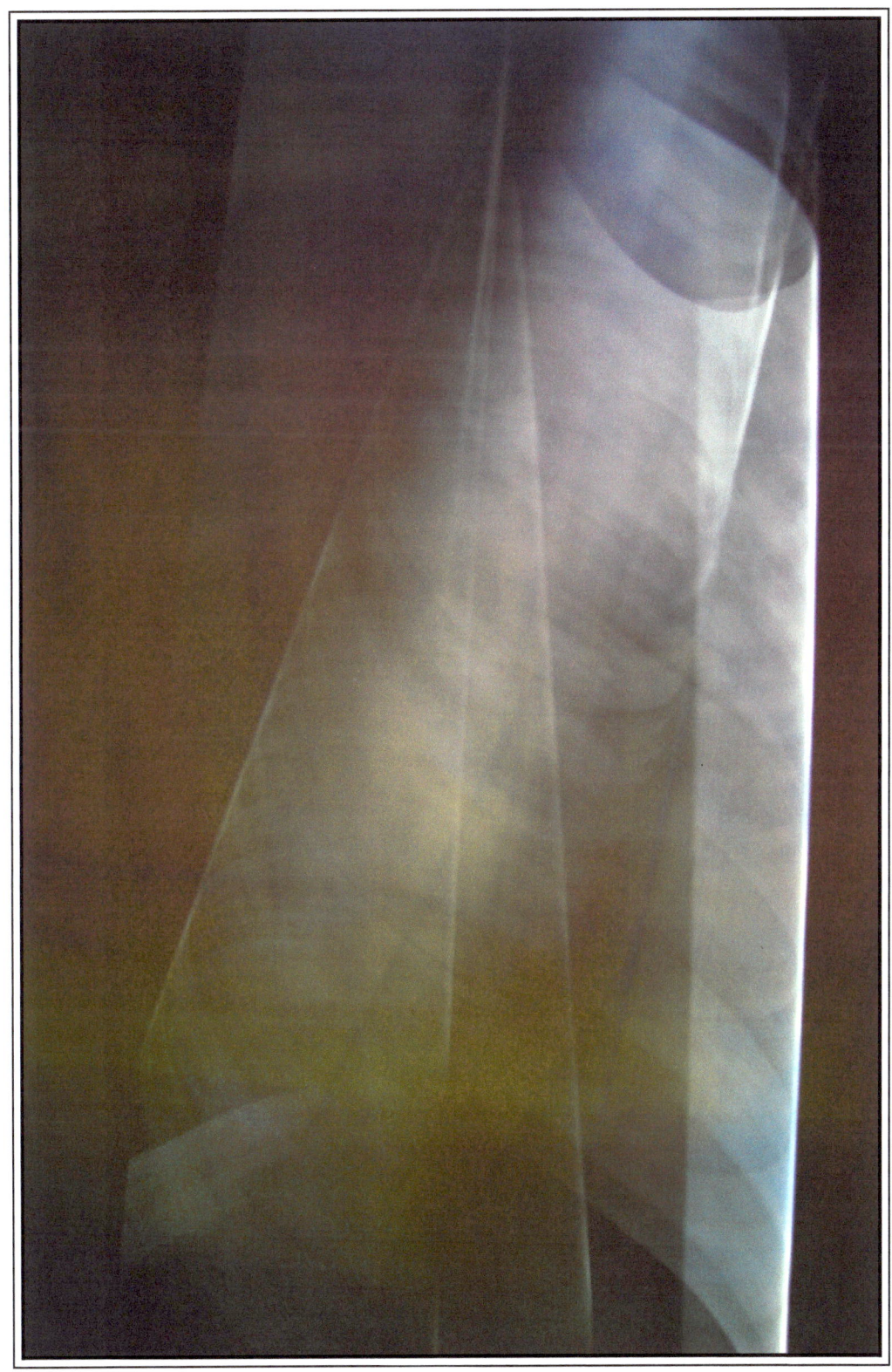

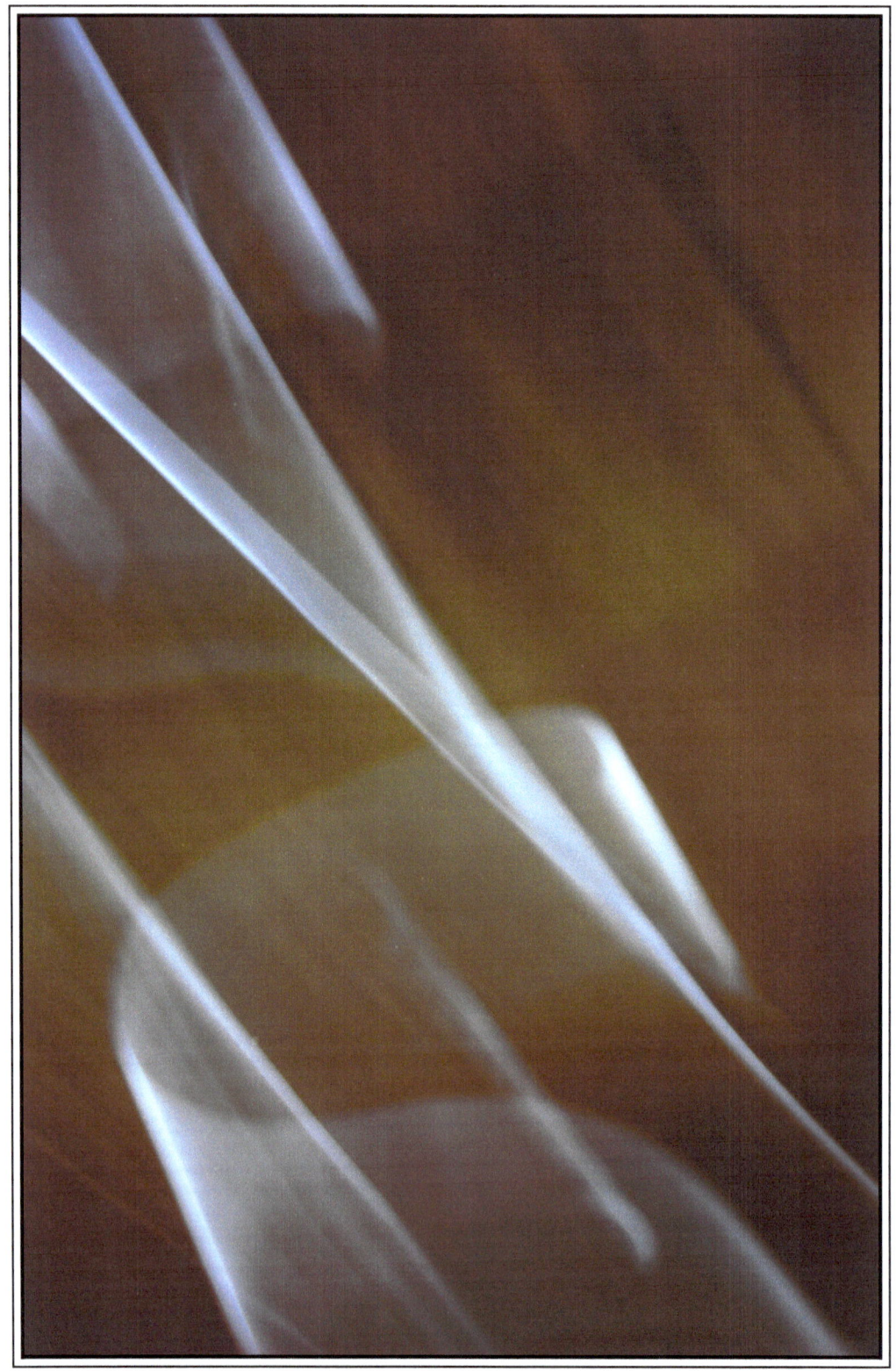

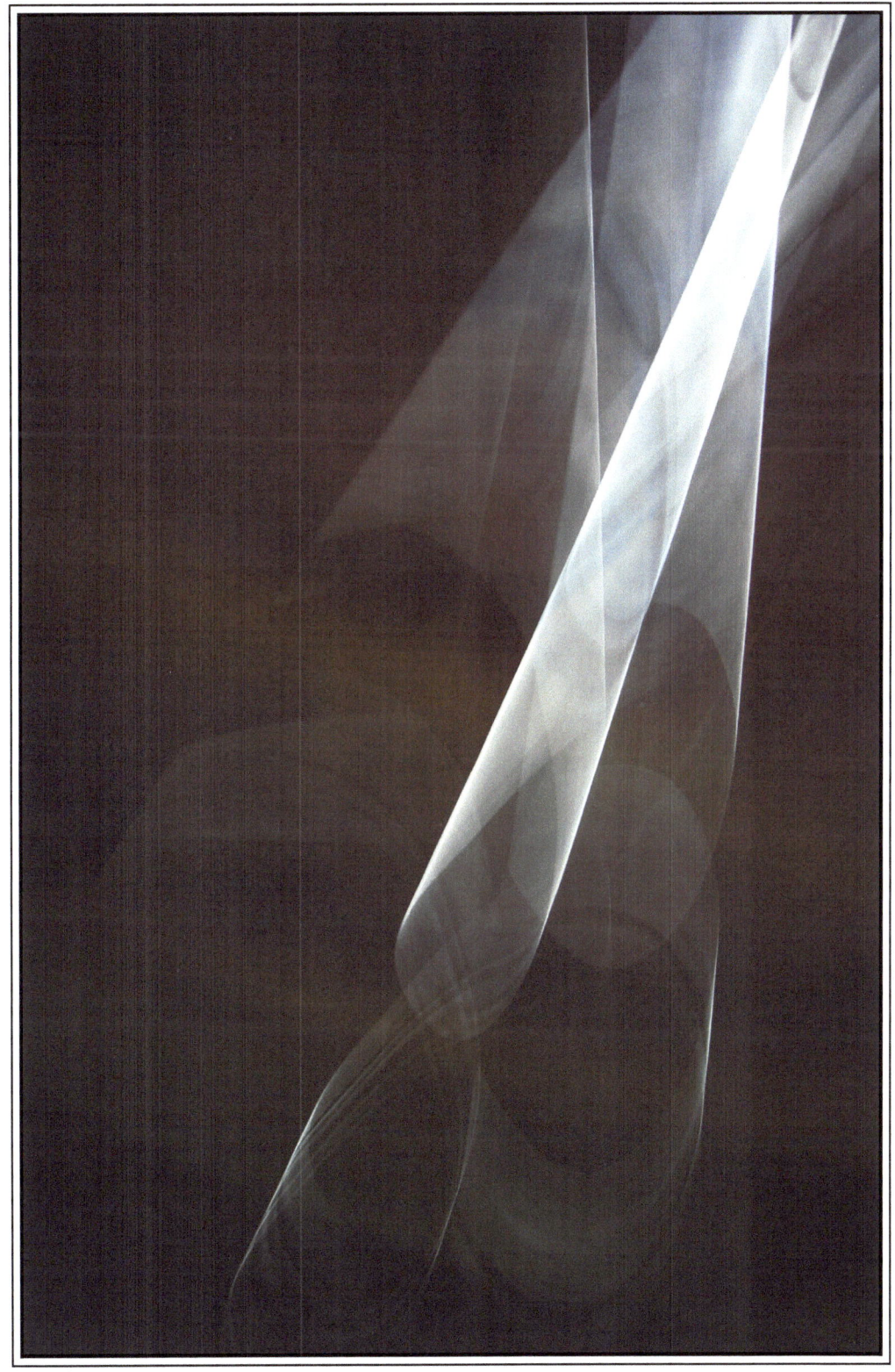

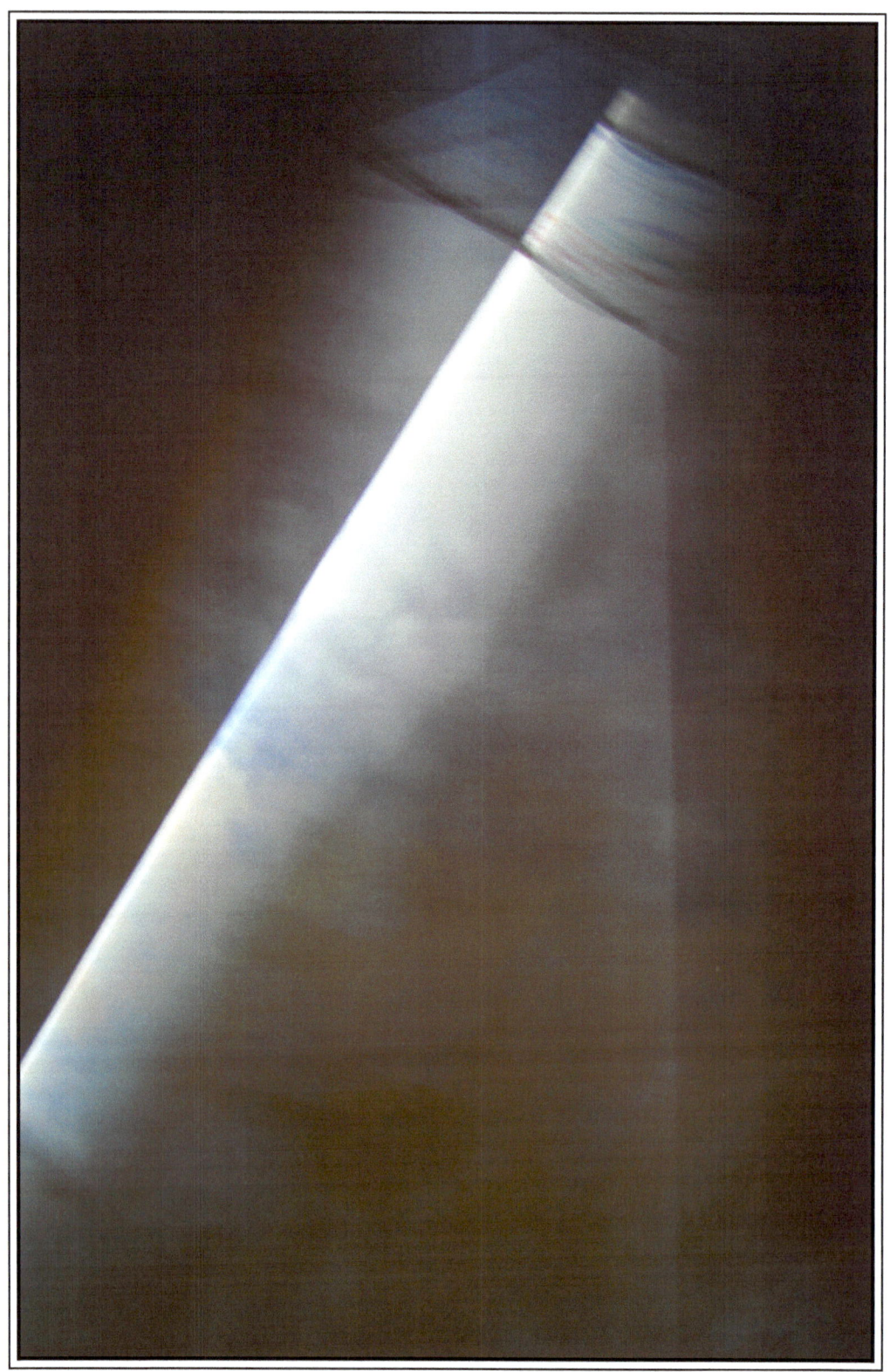

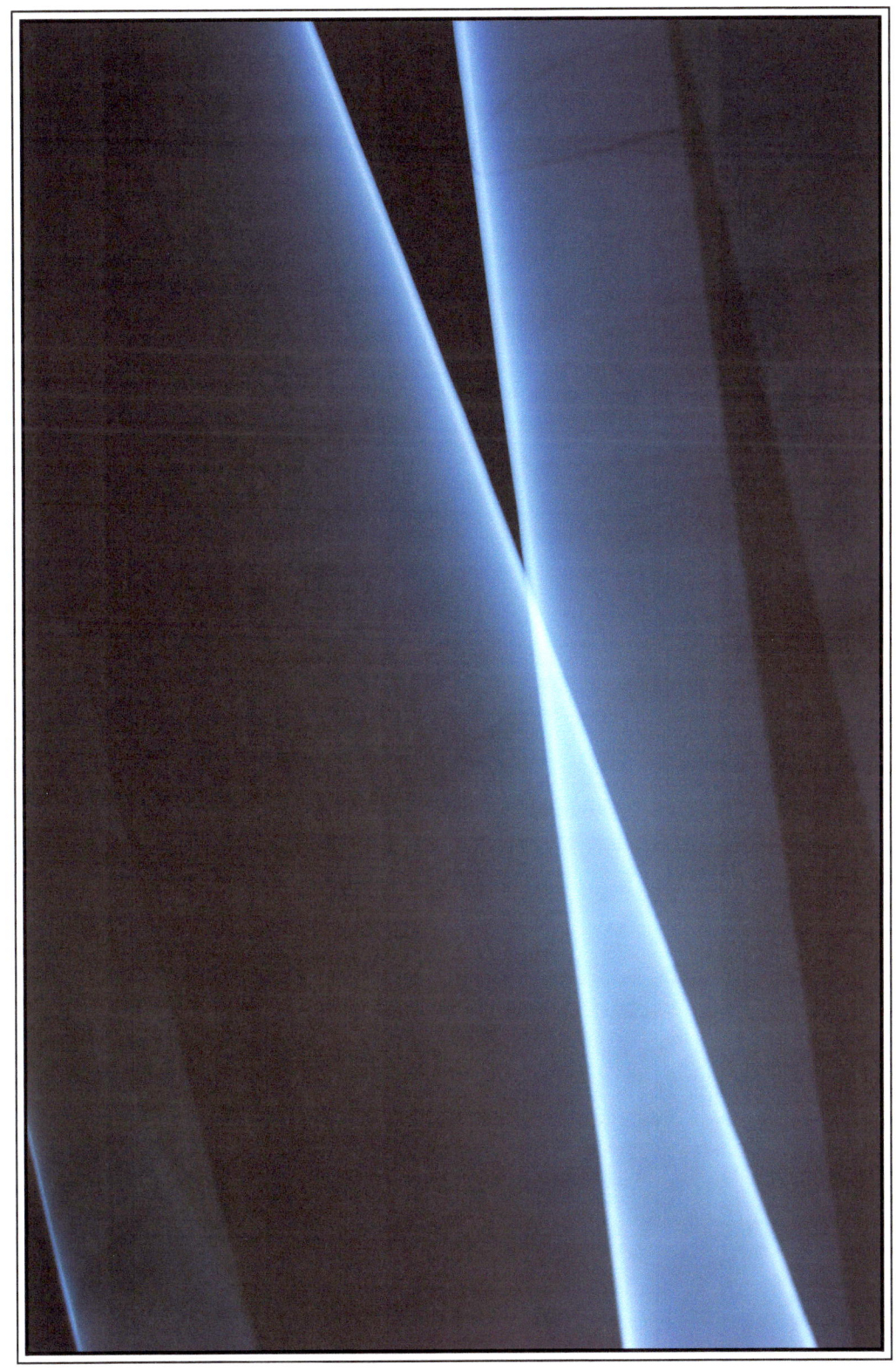

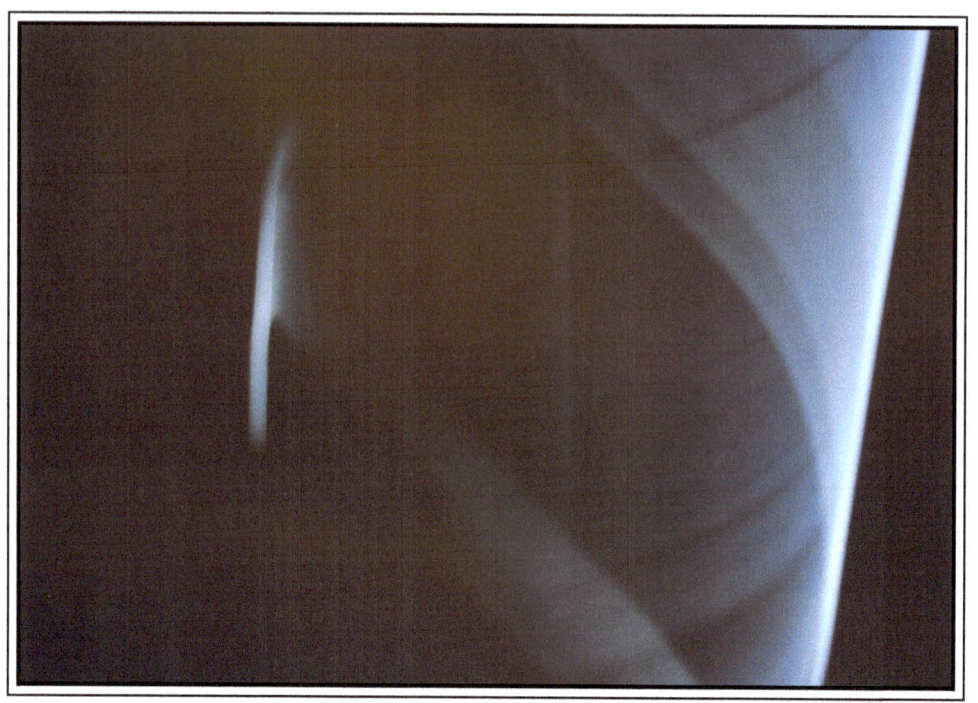

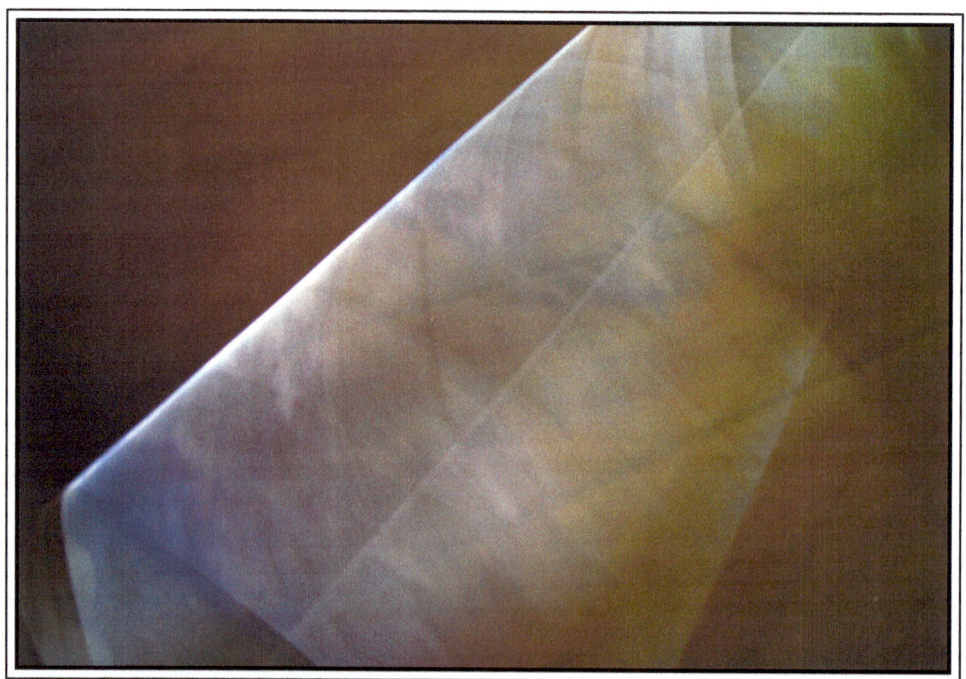

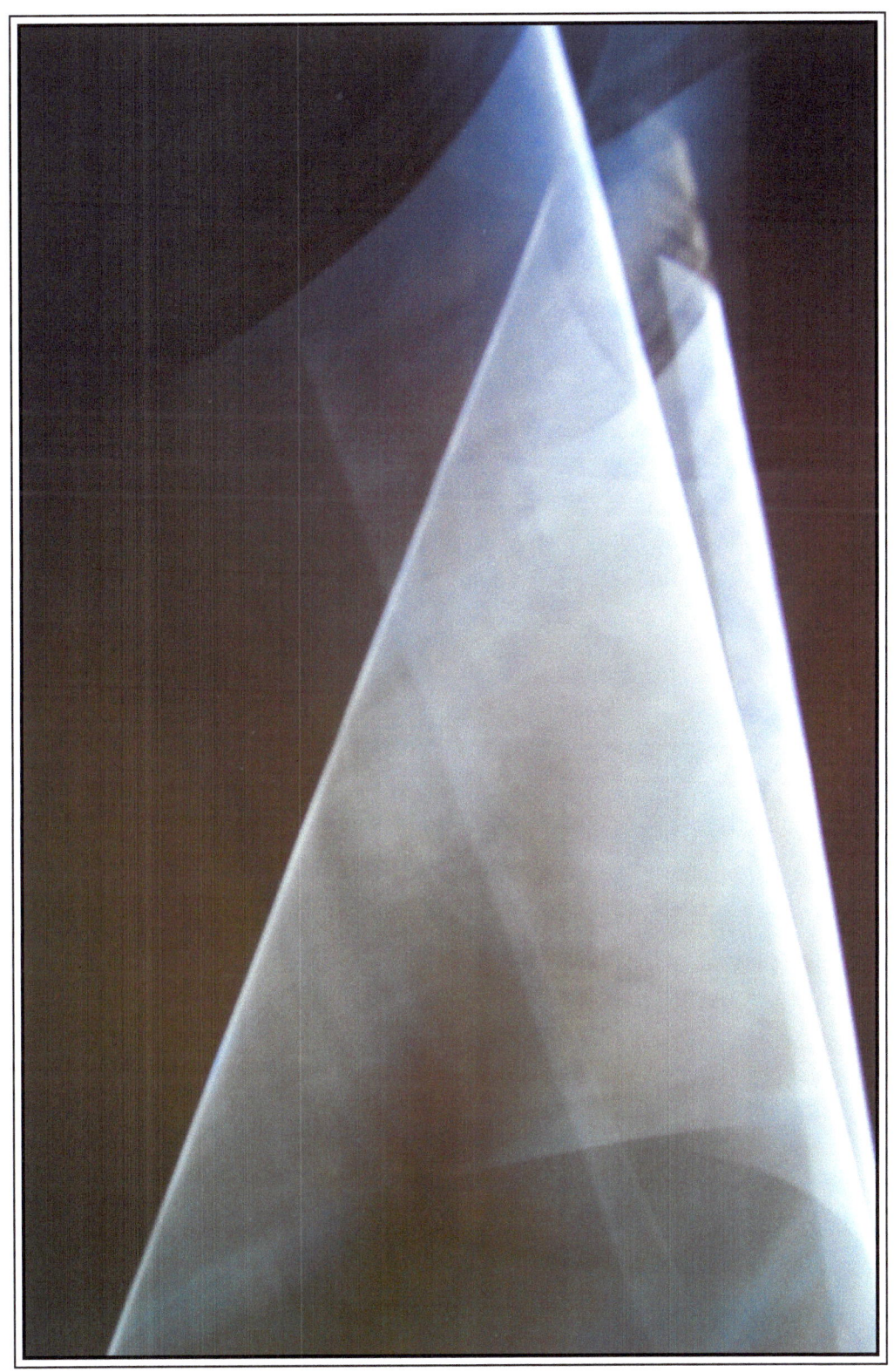

Pipe Abstracts

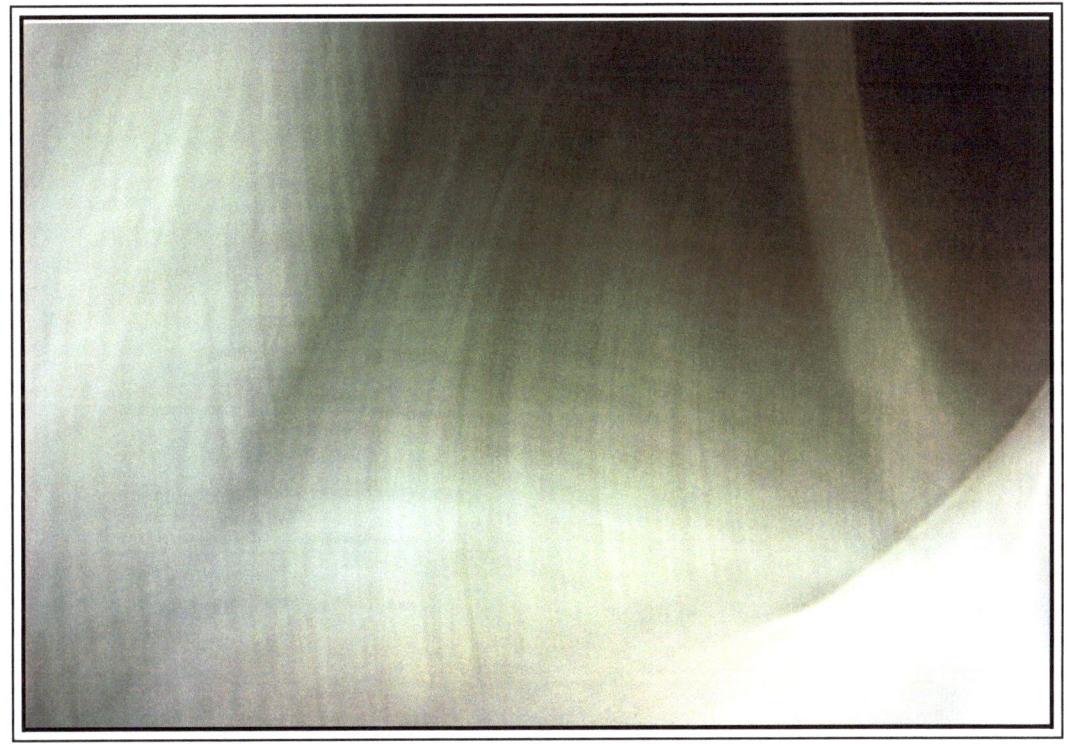

While at a construction site I found these pipes that were being stored for eventual use. I wasn't sure why but I started taking the photos at dusk, without too much light. The slow movement and slow shutter speed provided these beautiful shapes and mysterious images. They are not of this world, but they are. They are man made pipes! How or why this happens really does not interest me as I am only a conduit to show you these photographs.

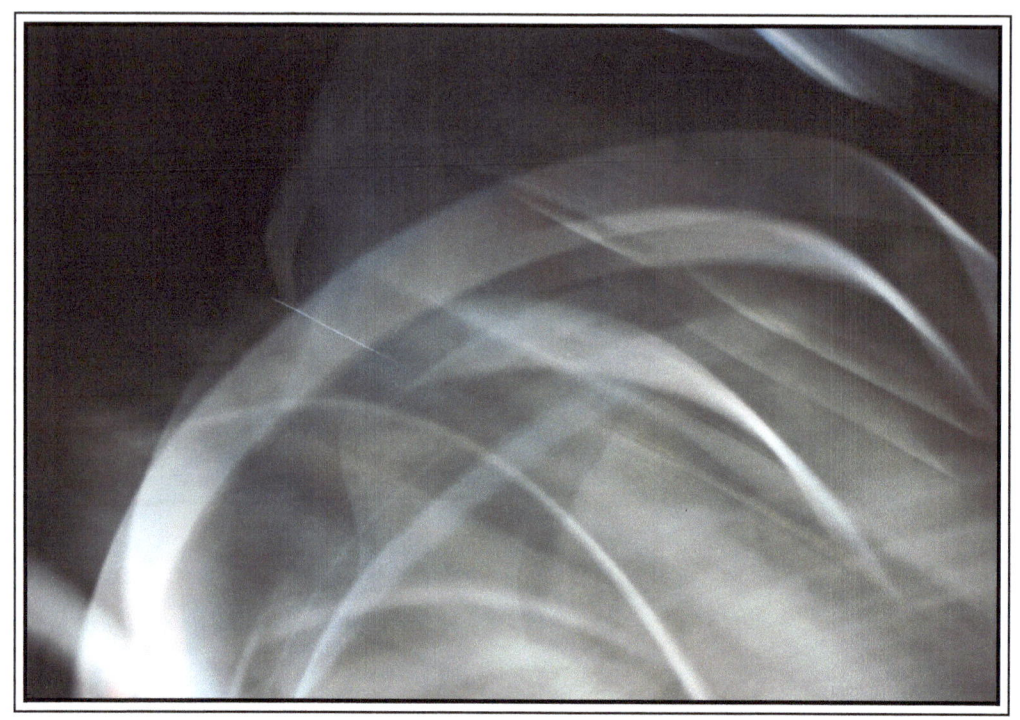

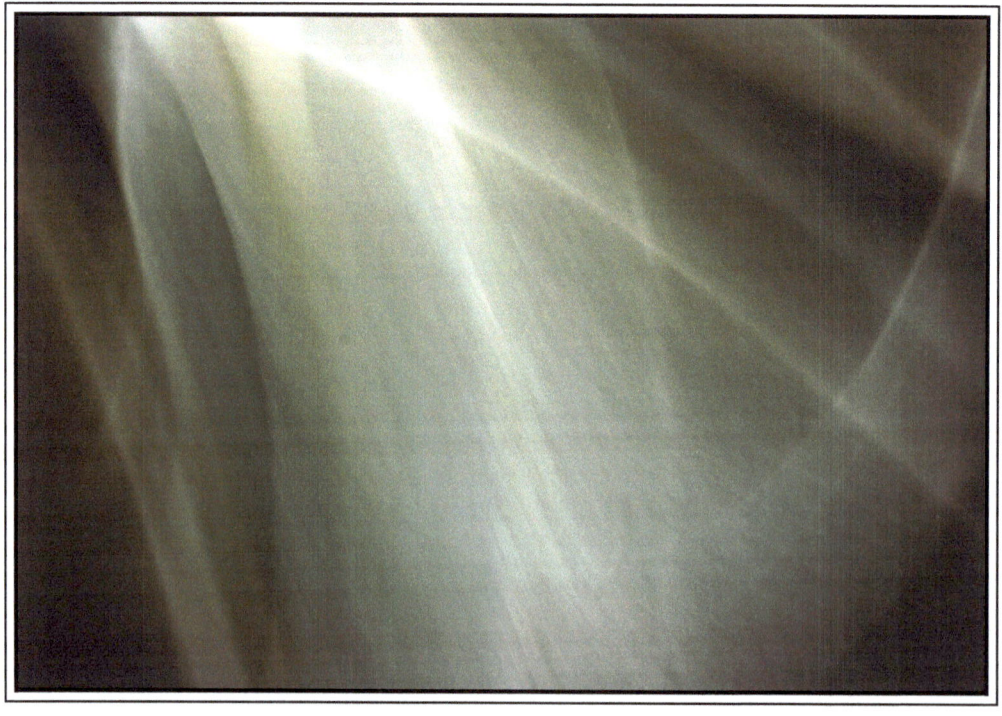

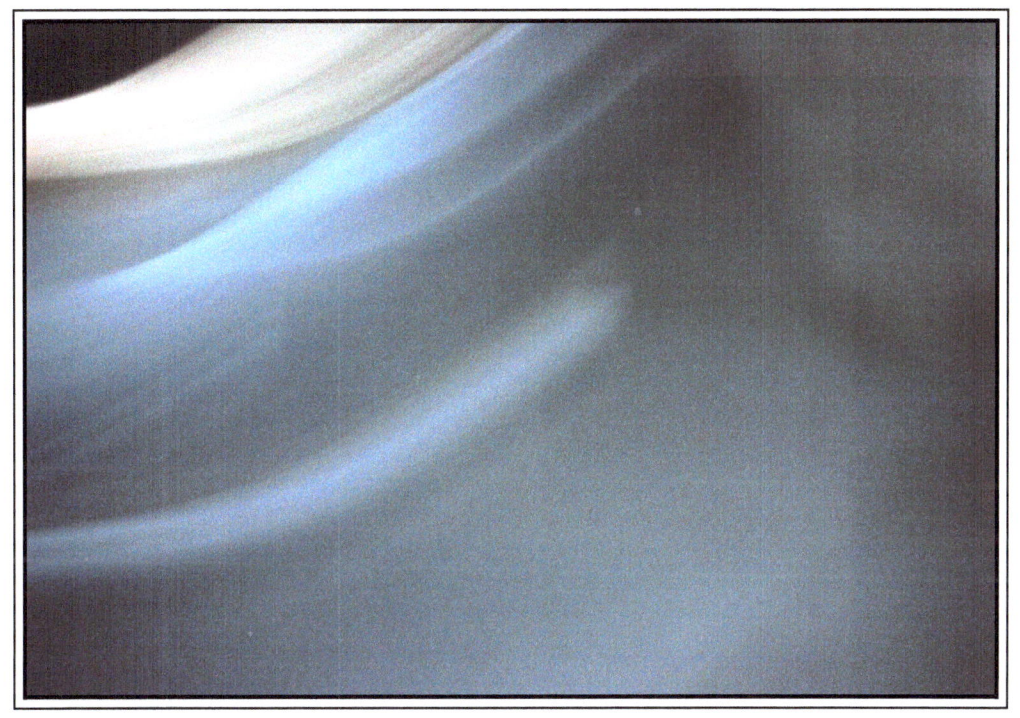
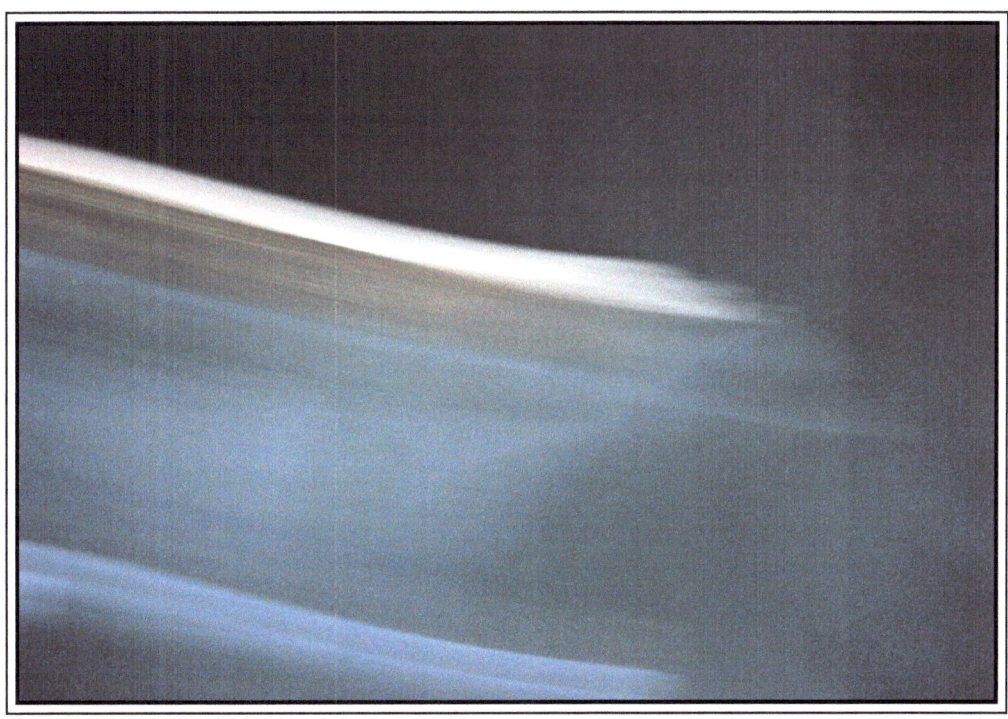

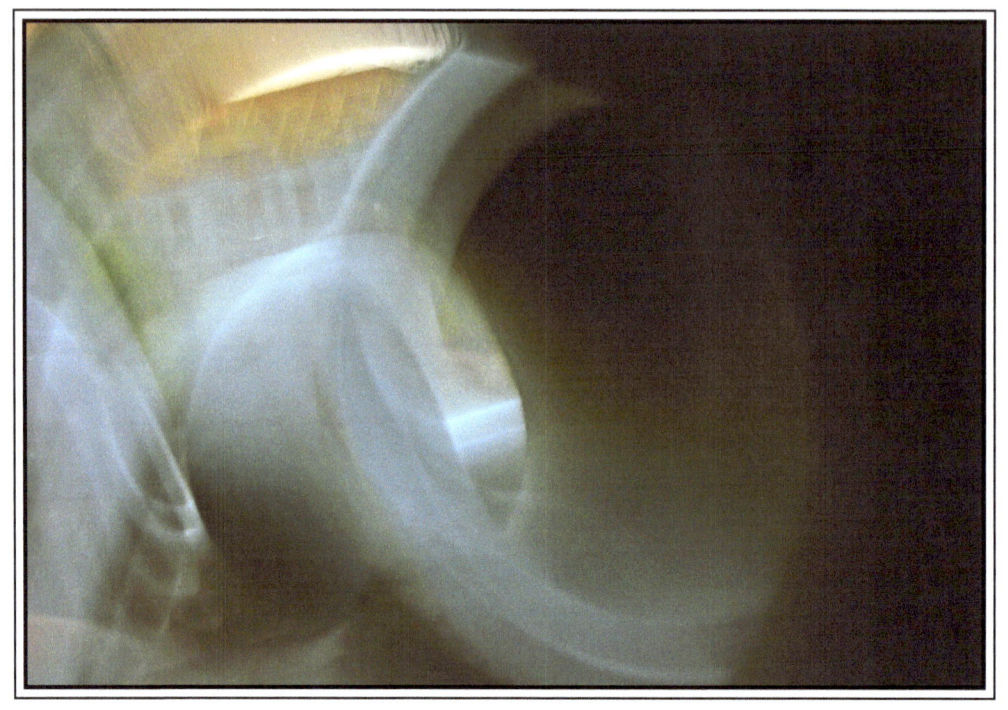

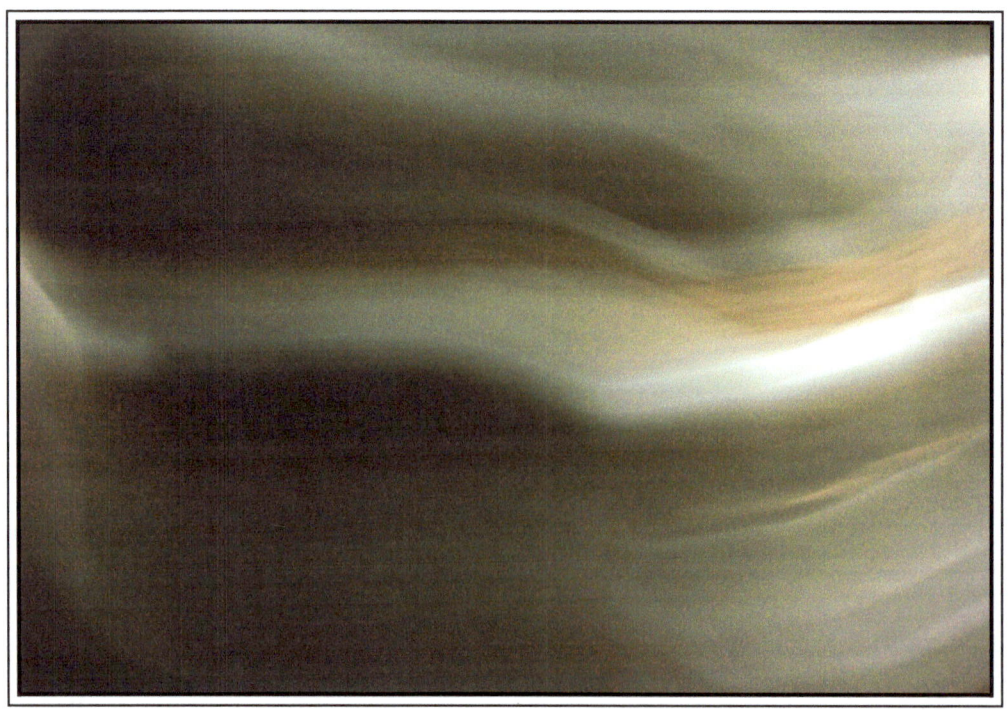

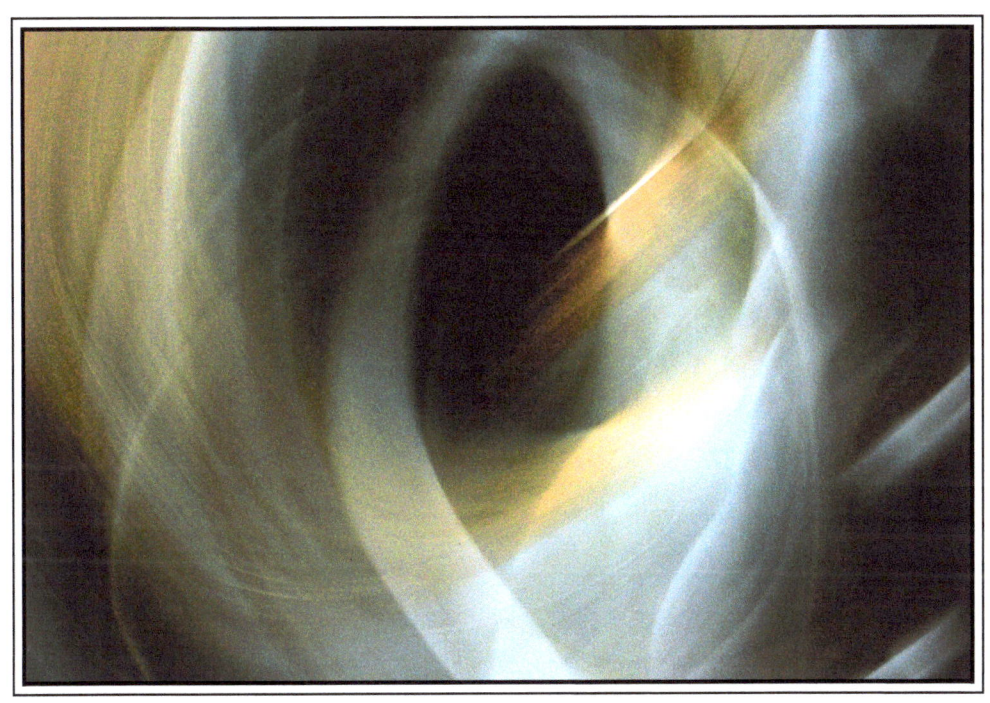

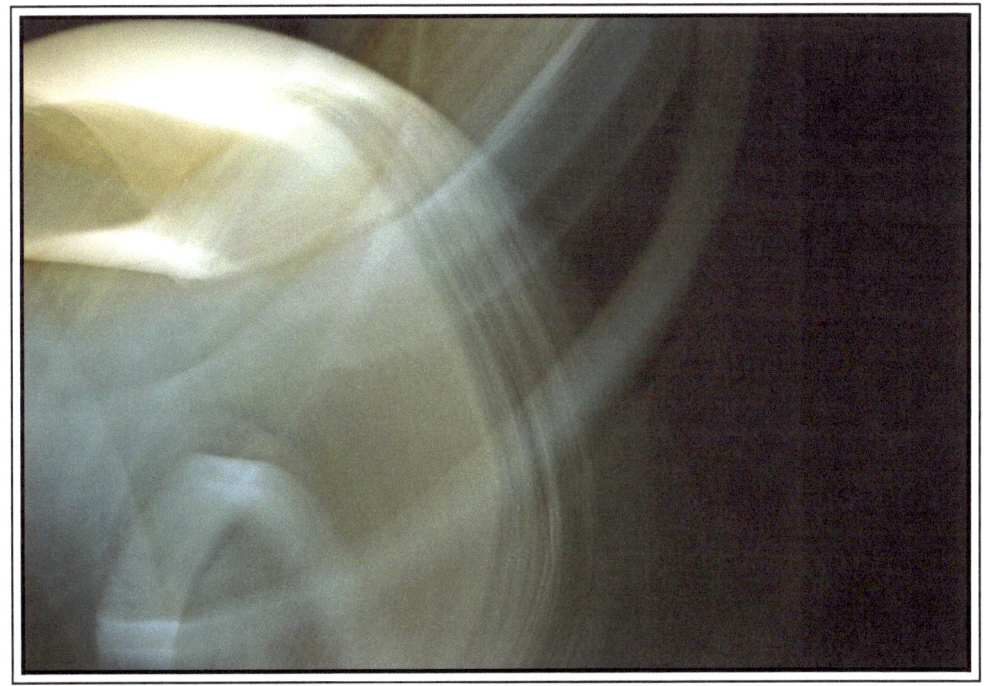

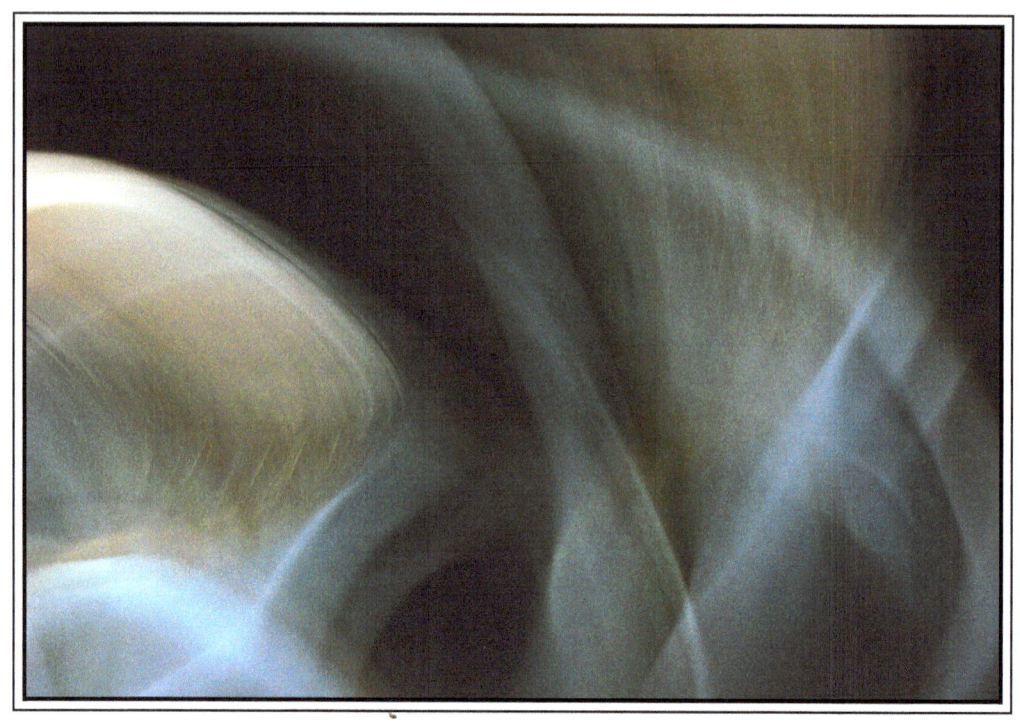

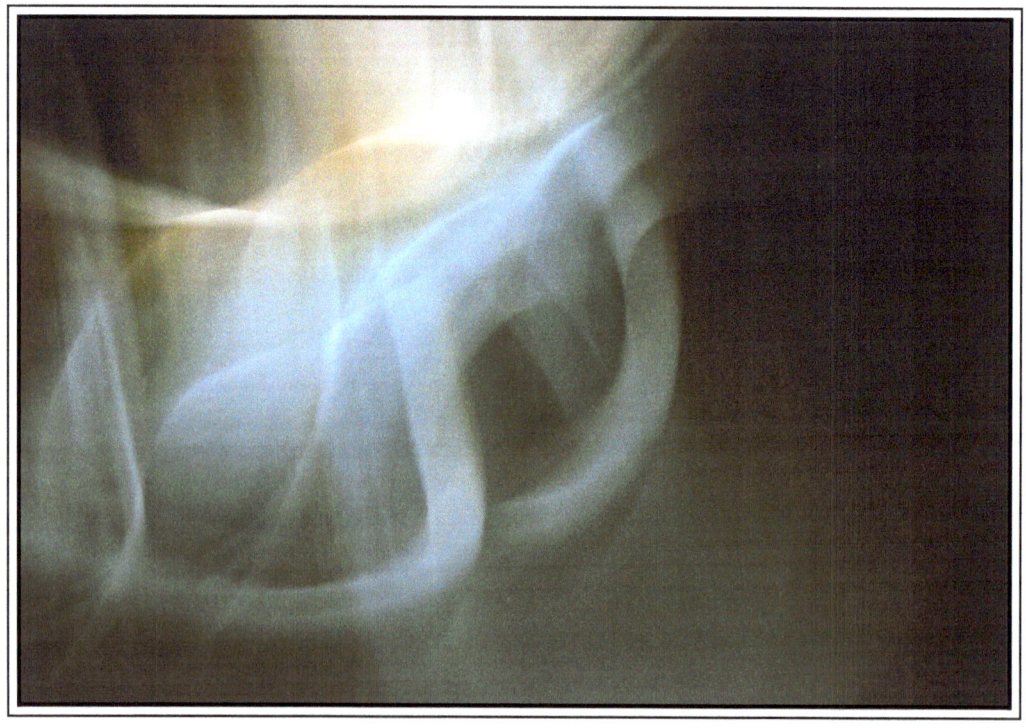

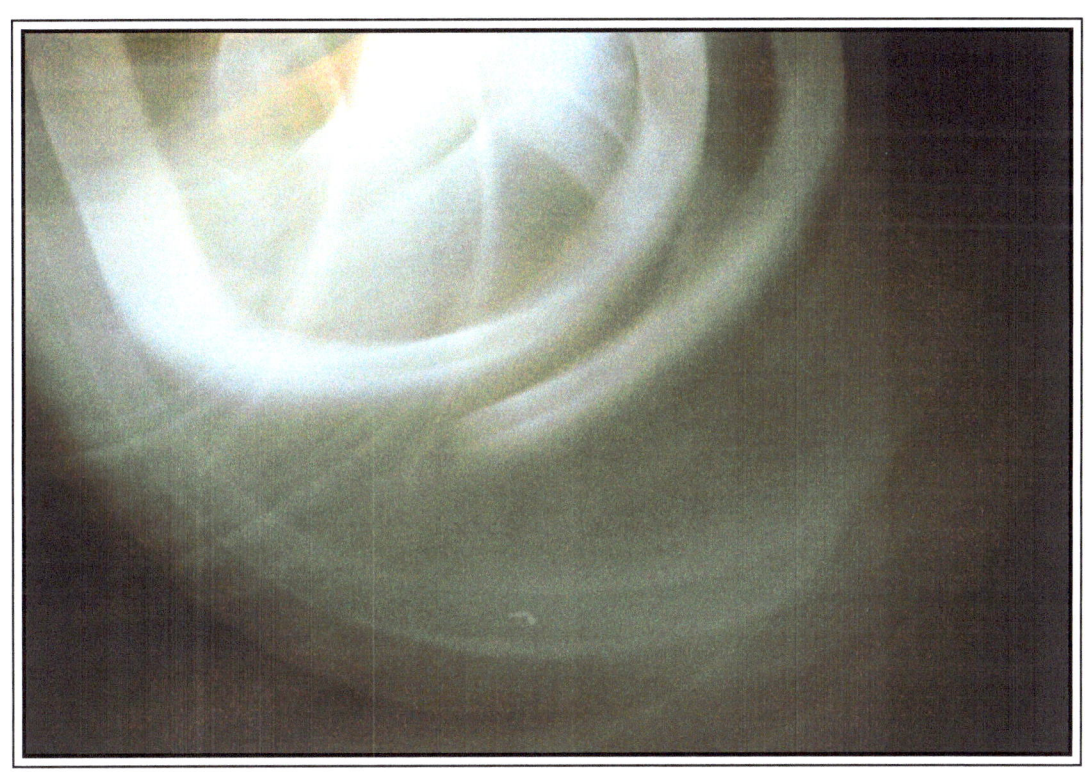

Scaffold Abstracts

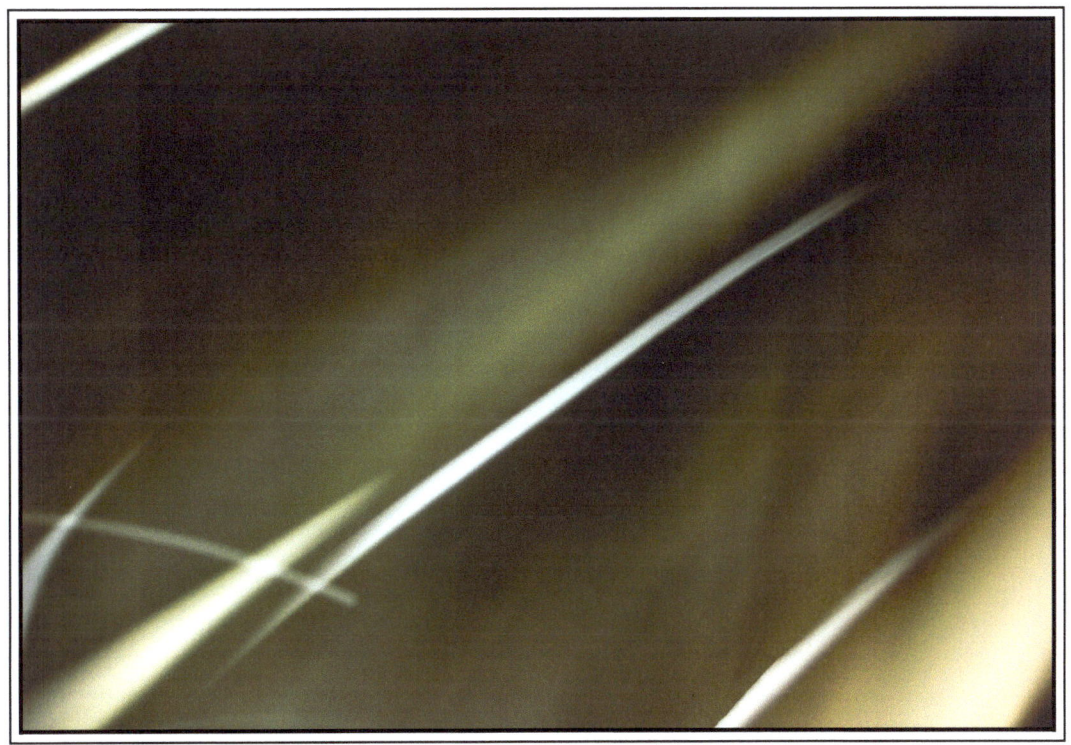

One day I saw a stack of scaffolds that were not being used. There were thousands of them neatly stacked to conserve space in maybe 100 piles. Some of these piles were stacked in a horizontal manner and other piles were stacked in a vertical manner. In either case, the spaces between the scaffolds provided these strange and somewhat beautiful images. I find myself wondering how this could have happened. I do not have the answer but the photographs are real and I feel privileged to provide them to you.

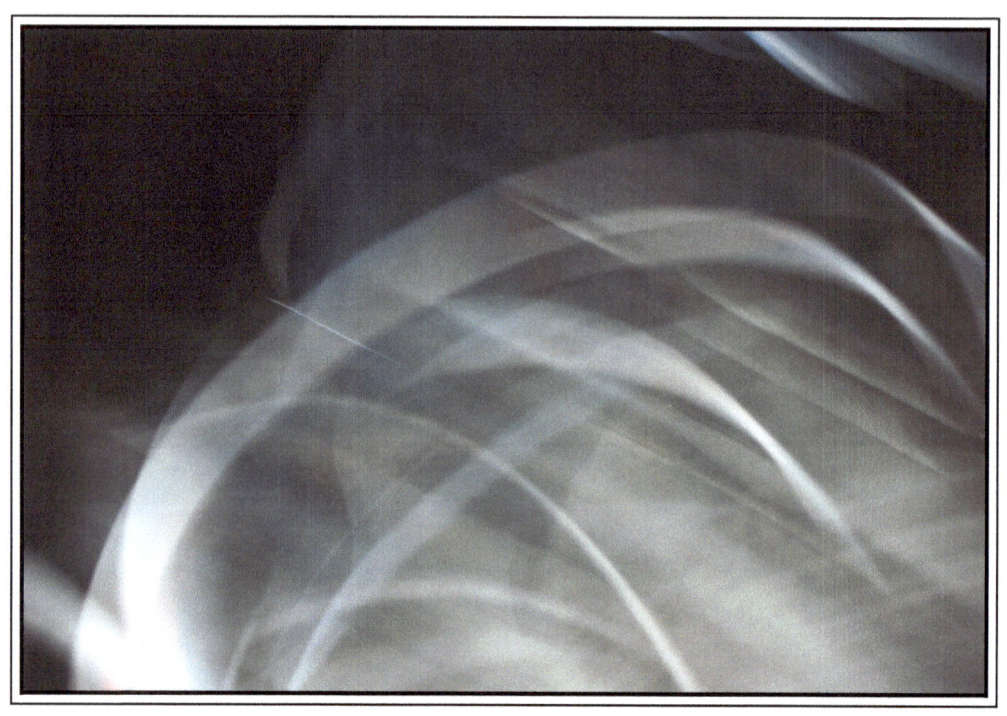

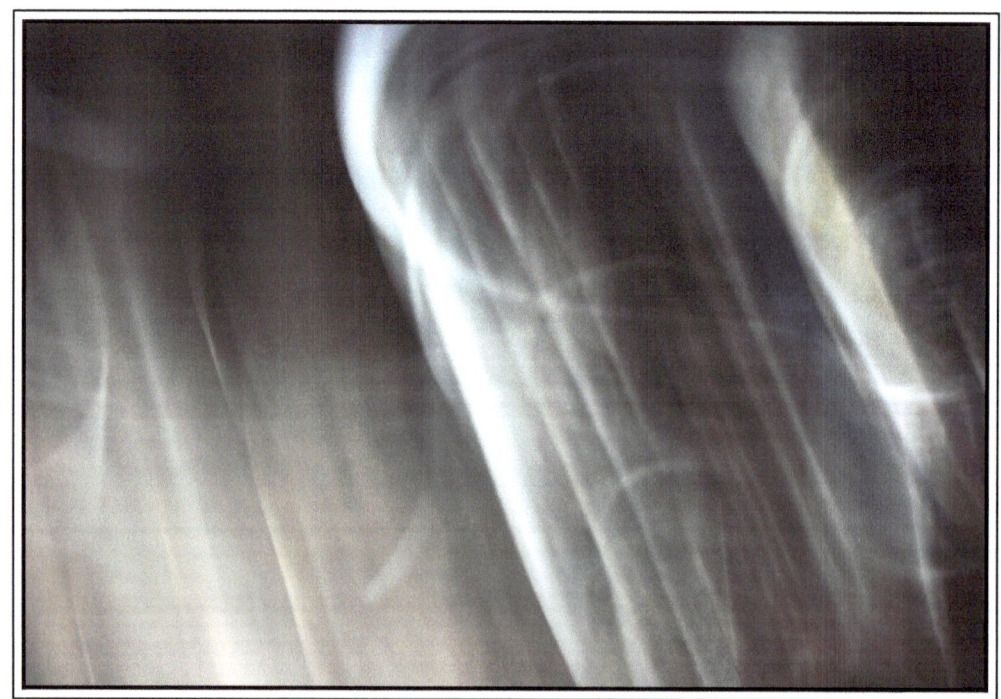

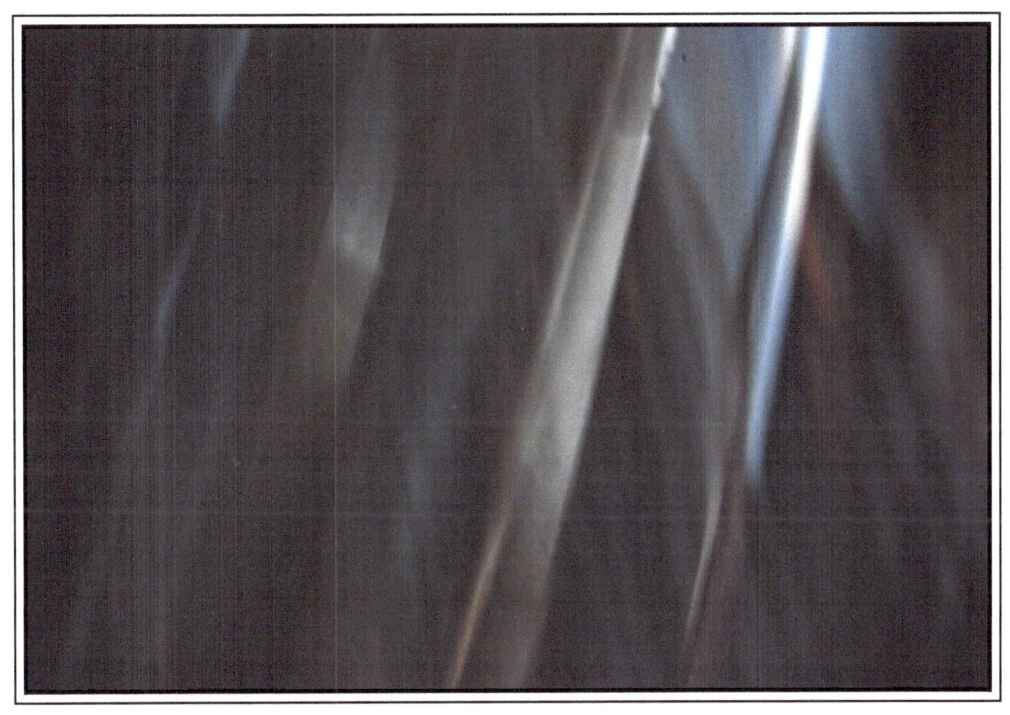

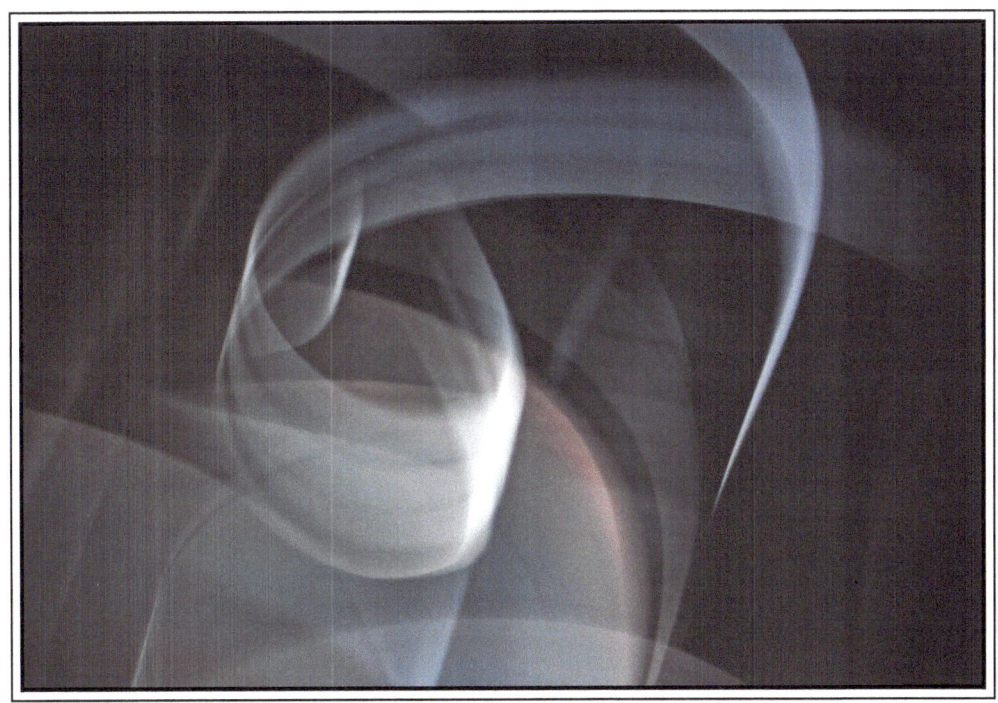

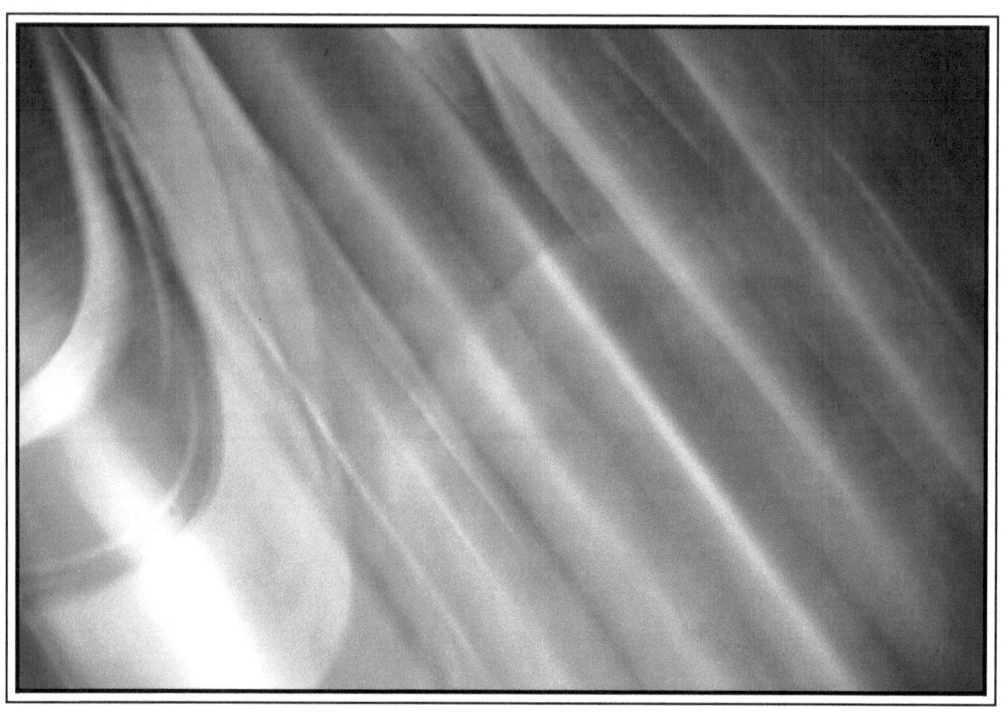

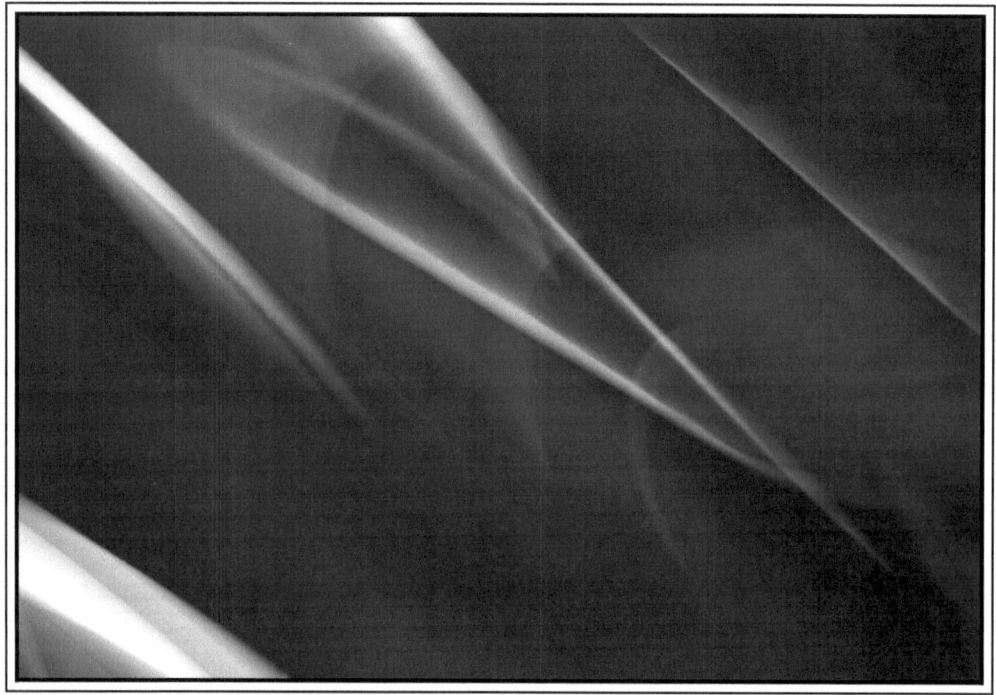

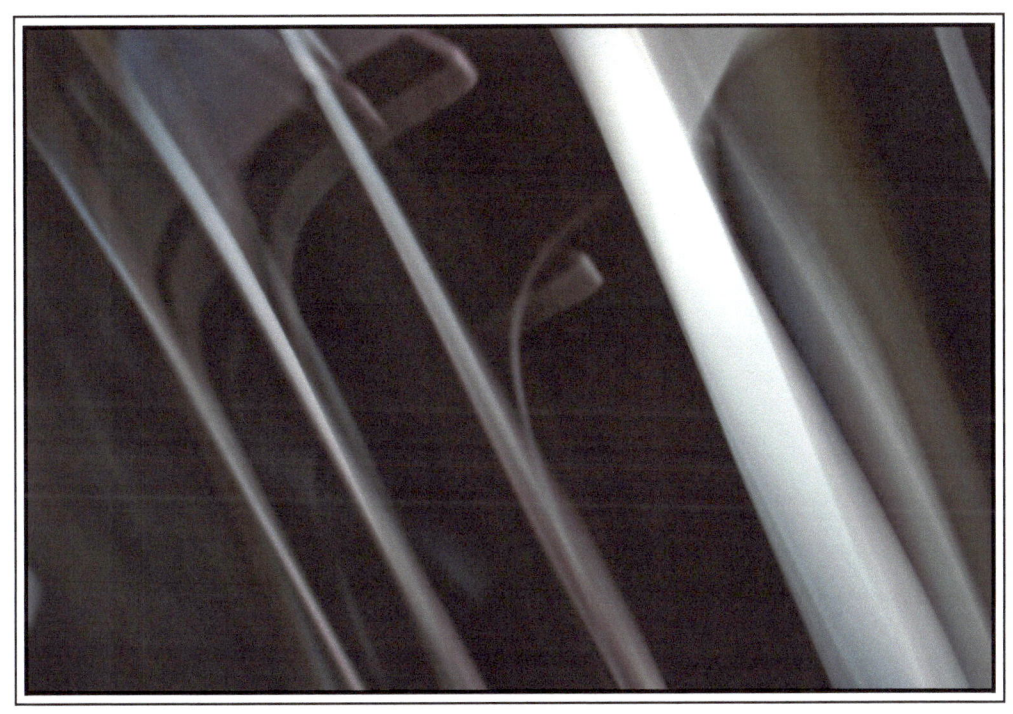

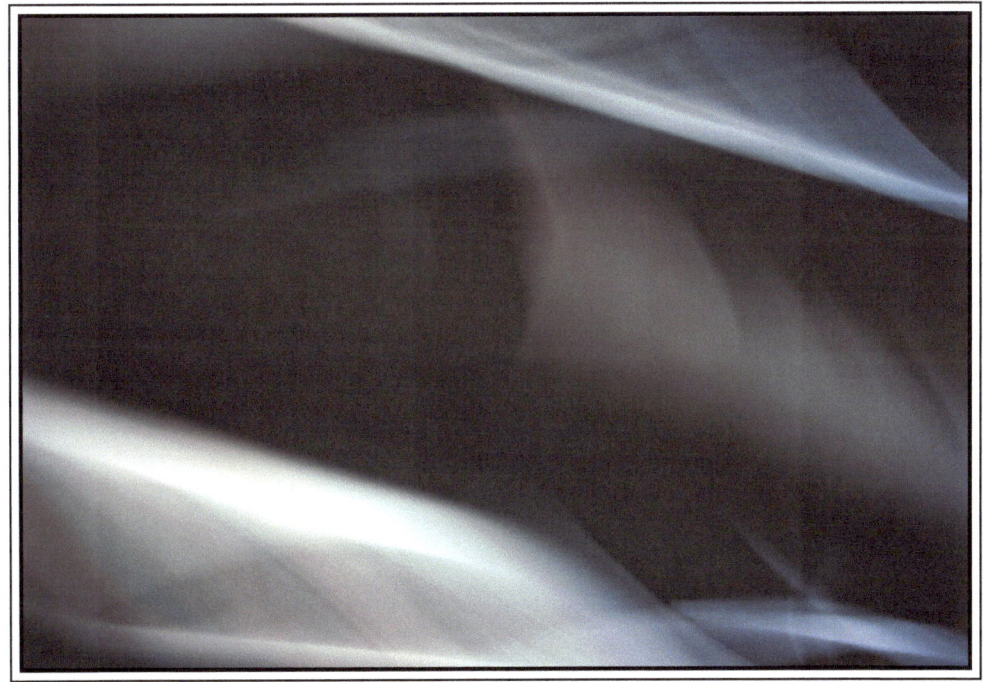

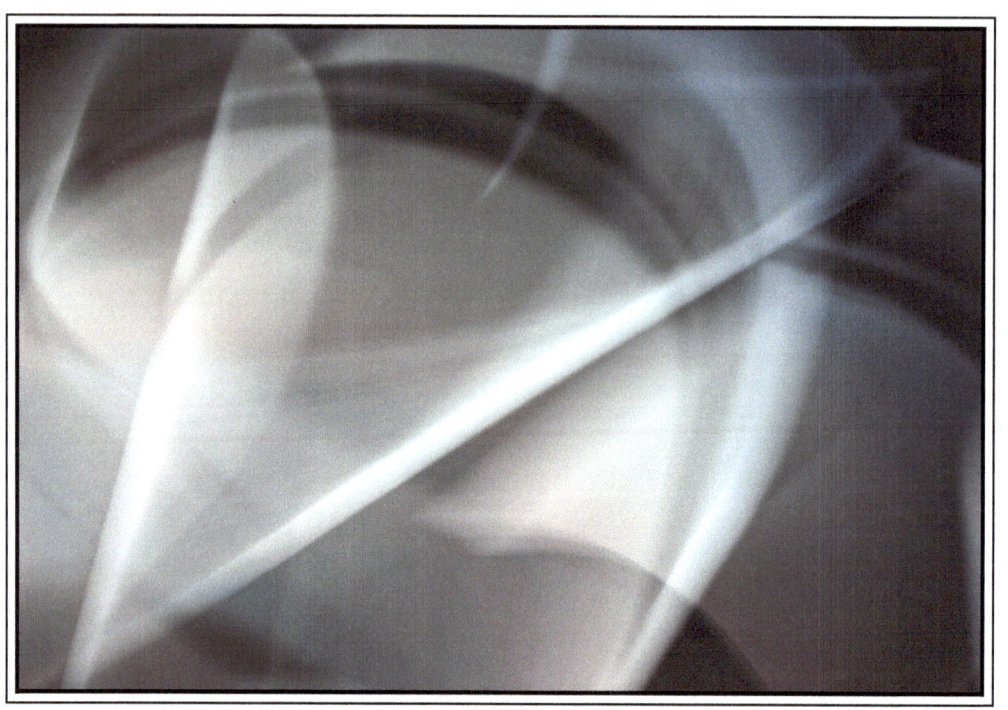

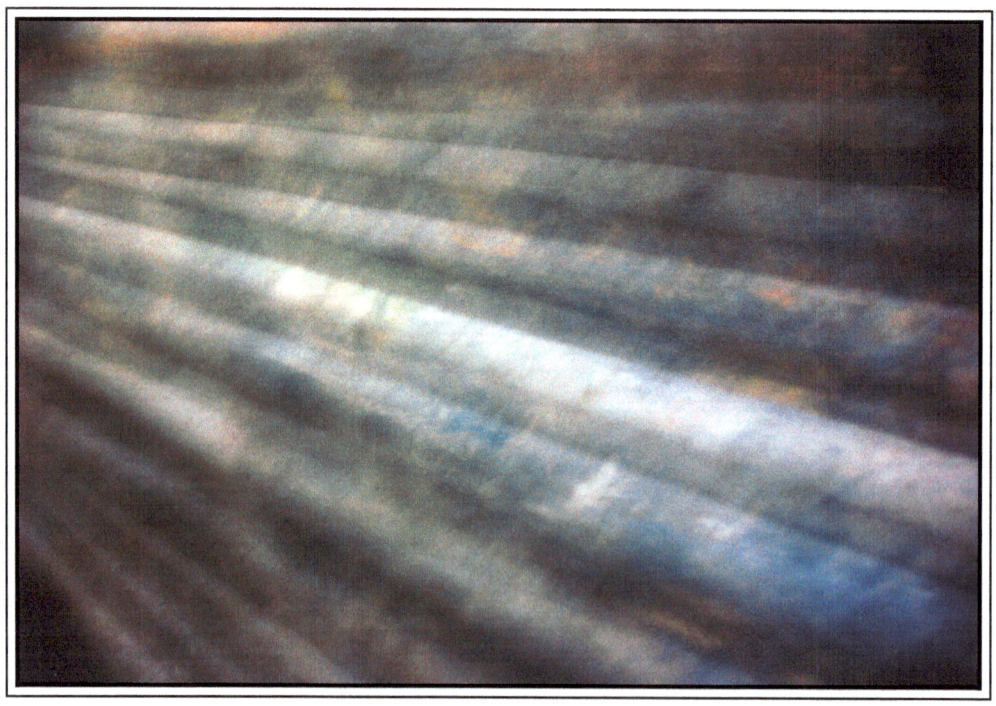

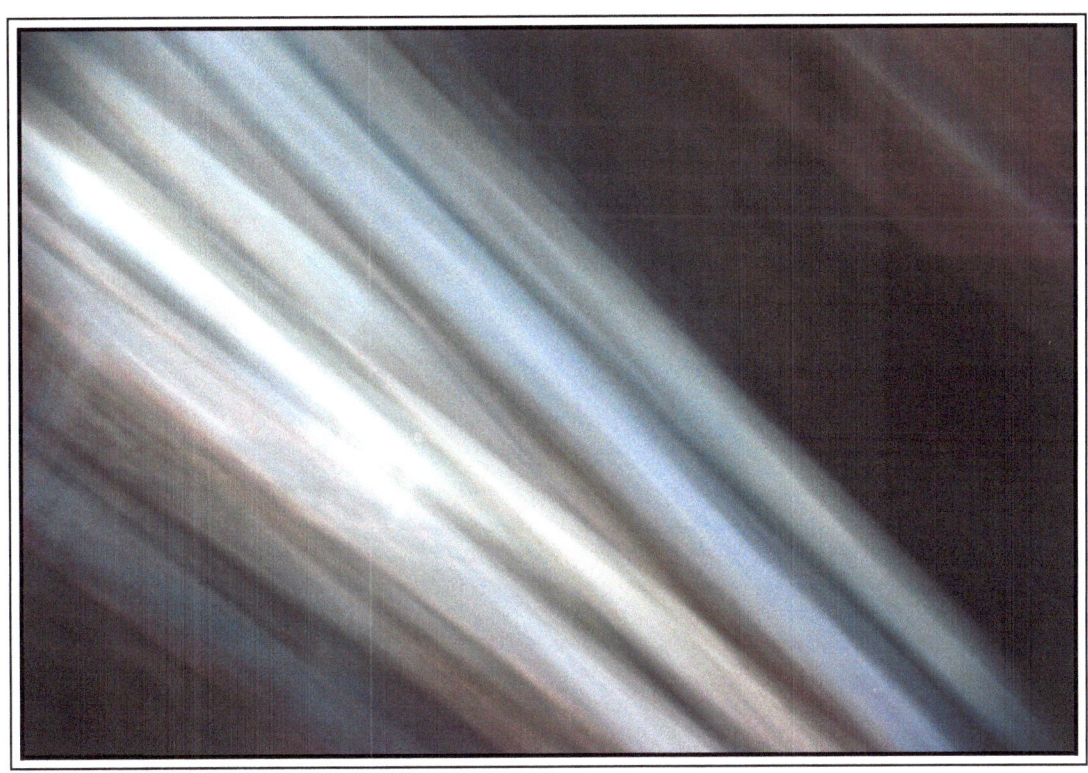

Underground Abstracts

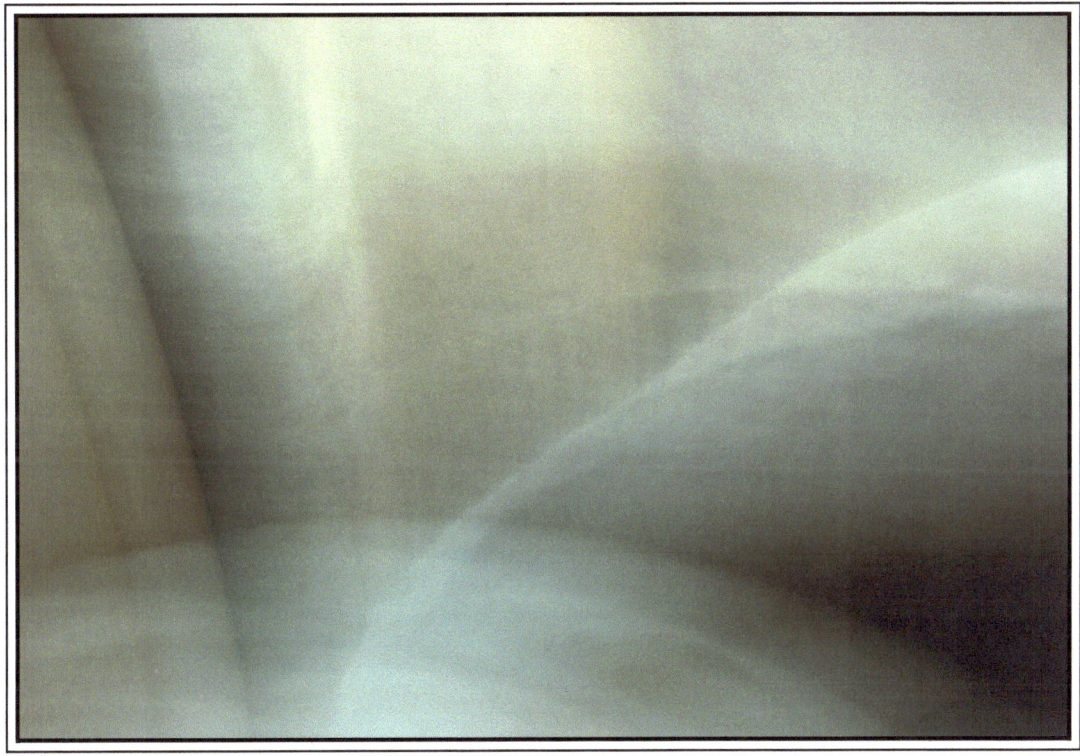

Underground drains, manholes and storm pipes have provided the source of these images. The shapes, the connections and the depth of some of these items provide the strange shapes and colors. Some of the photographs remind me of something found in deep space. They are cosmic shapes and forms that seem that we are not familiar with. I continually look at these photographs today and I am in awe of what I am able to present to you.

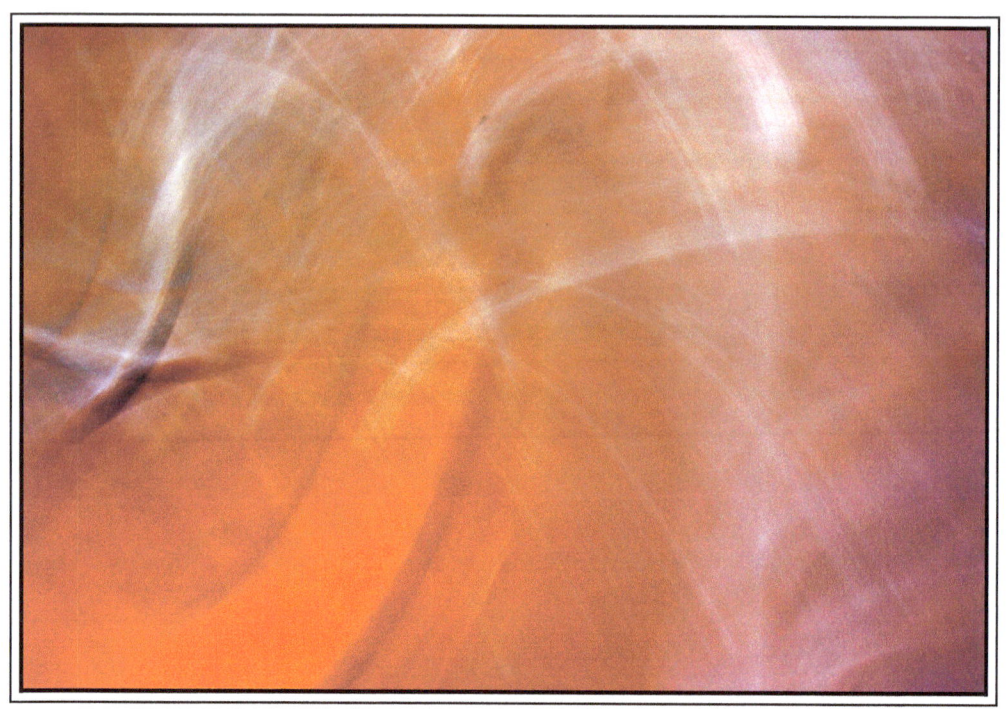

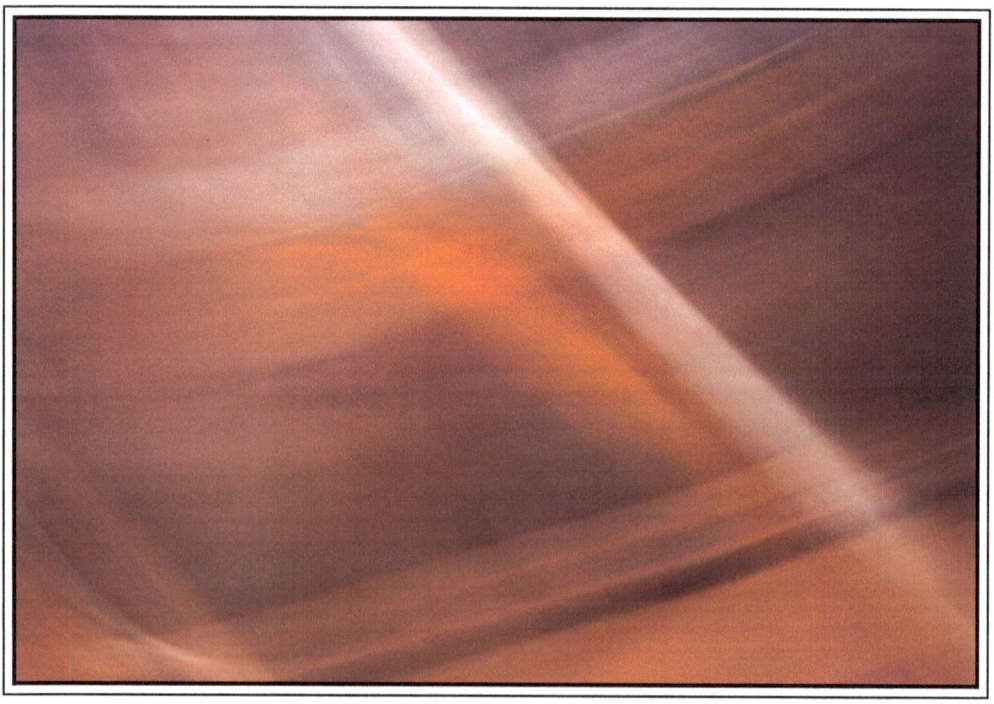

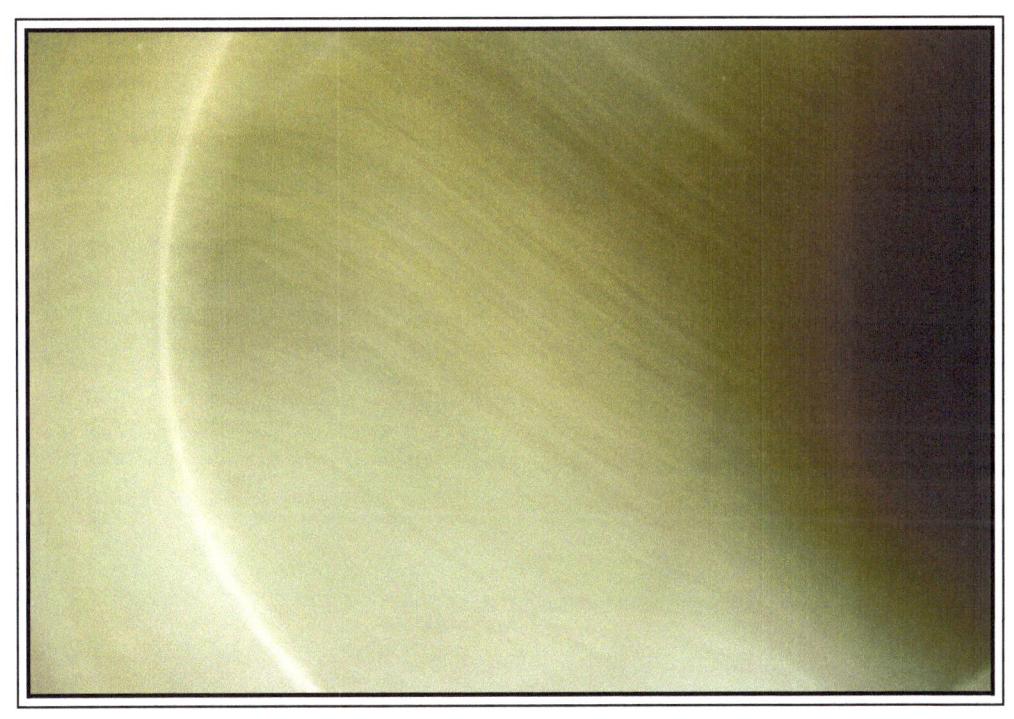

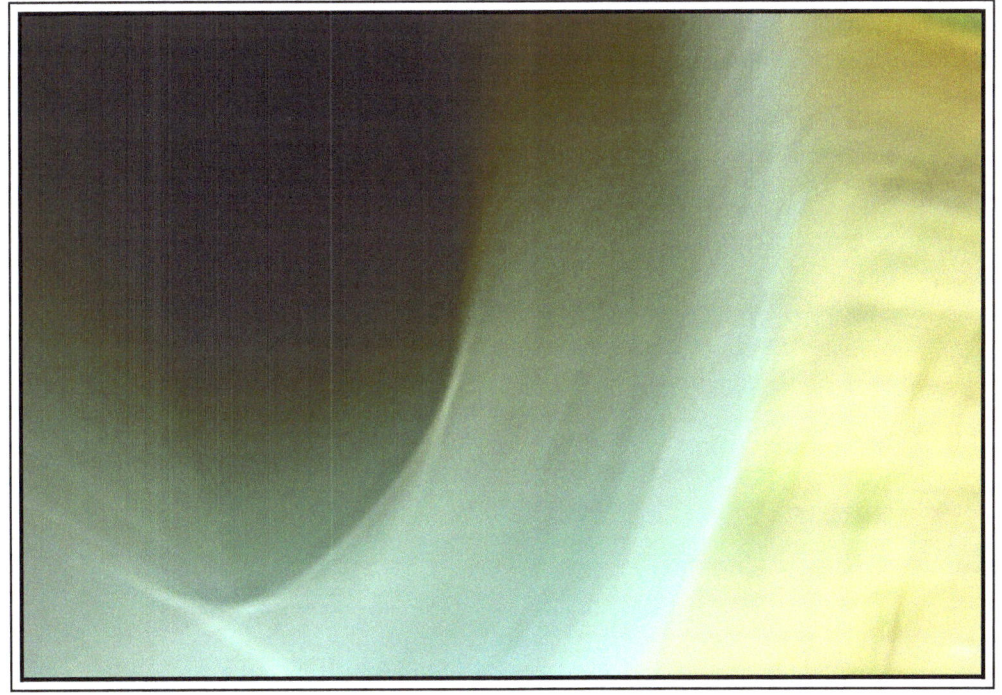

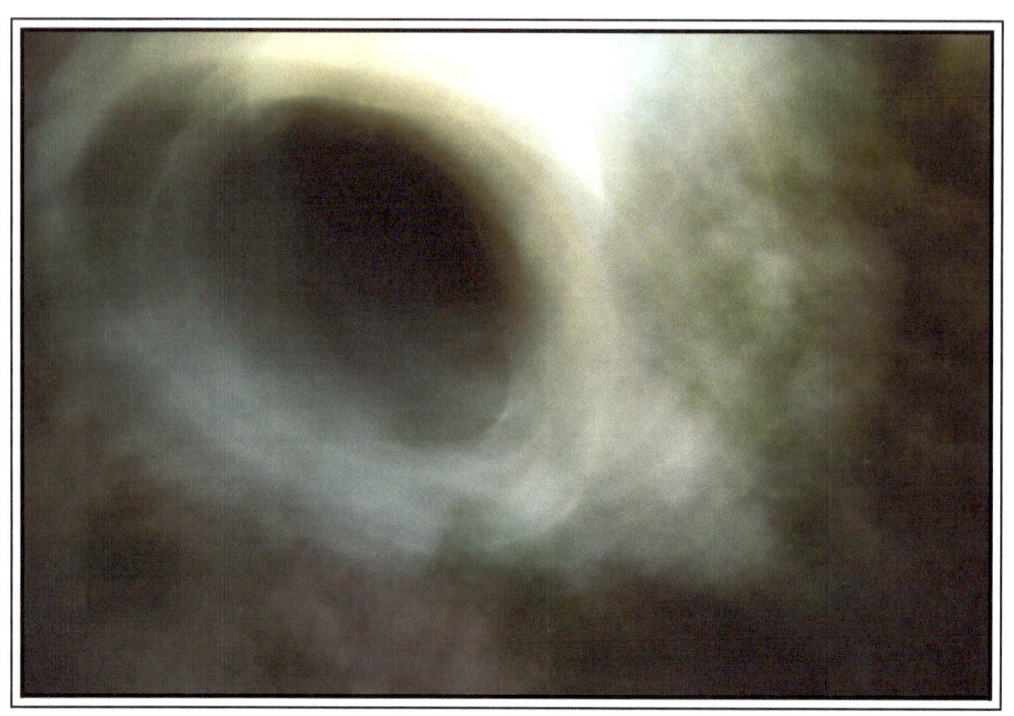

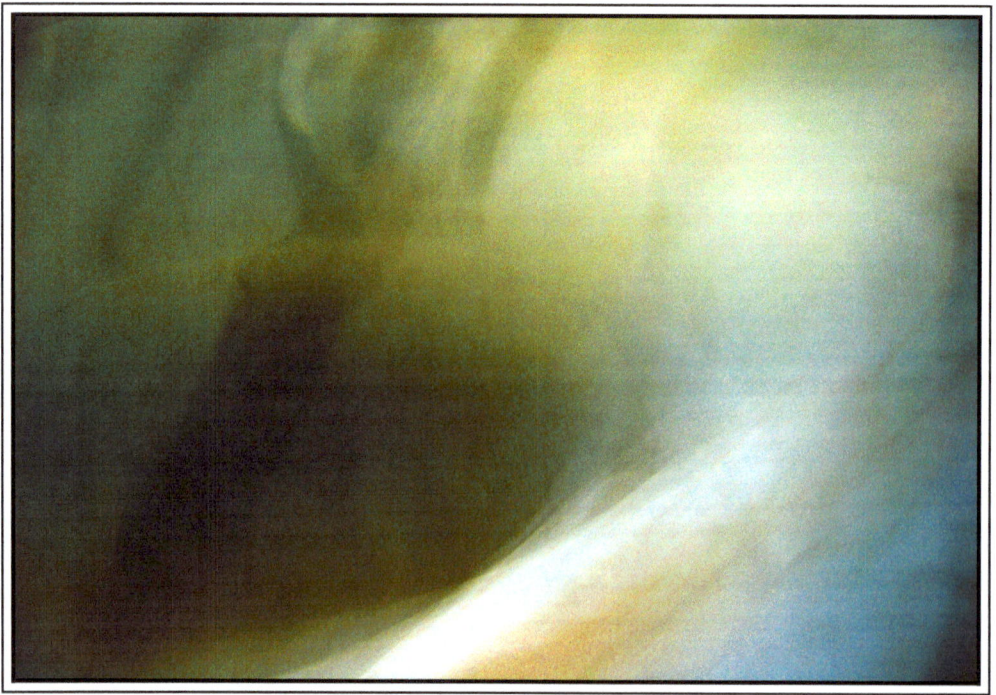

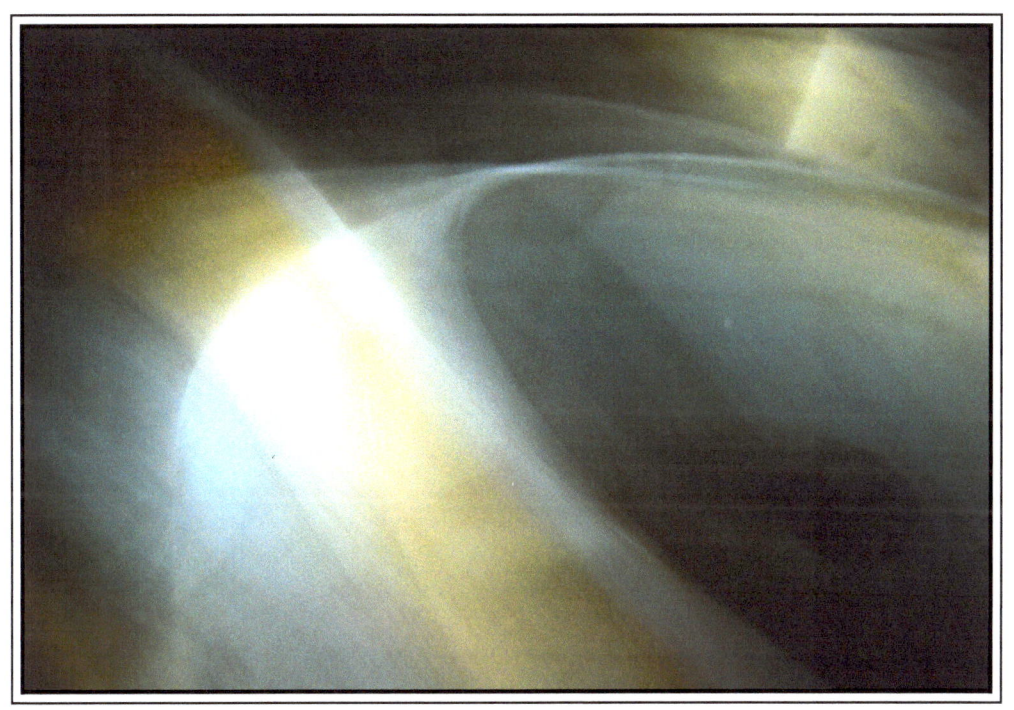

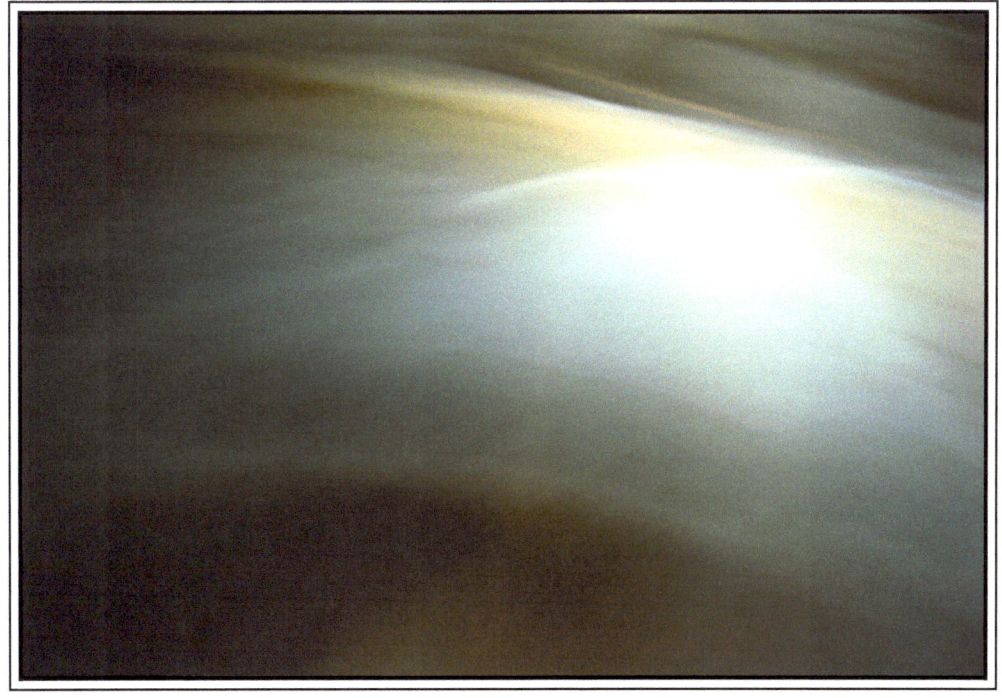

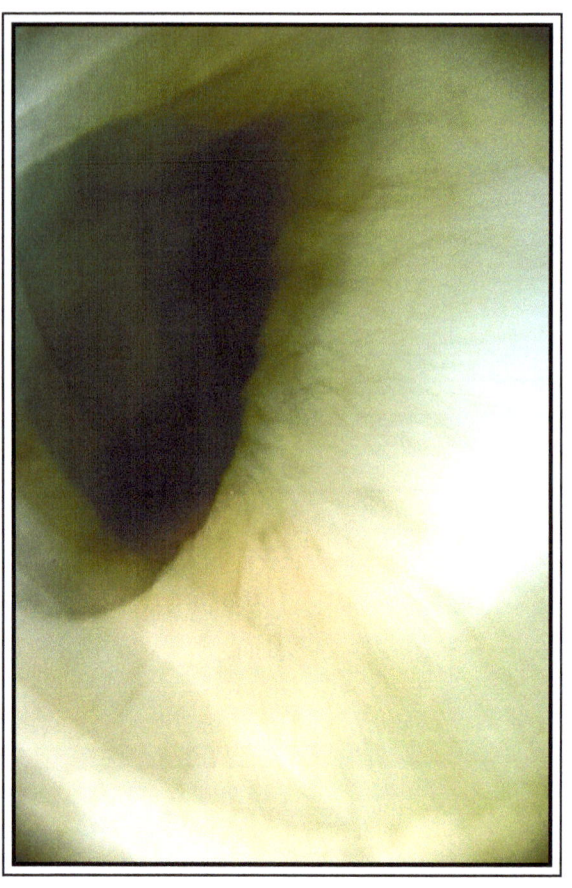
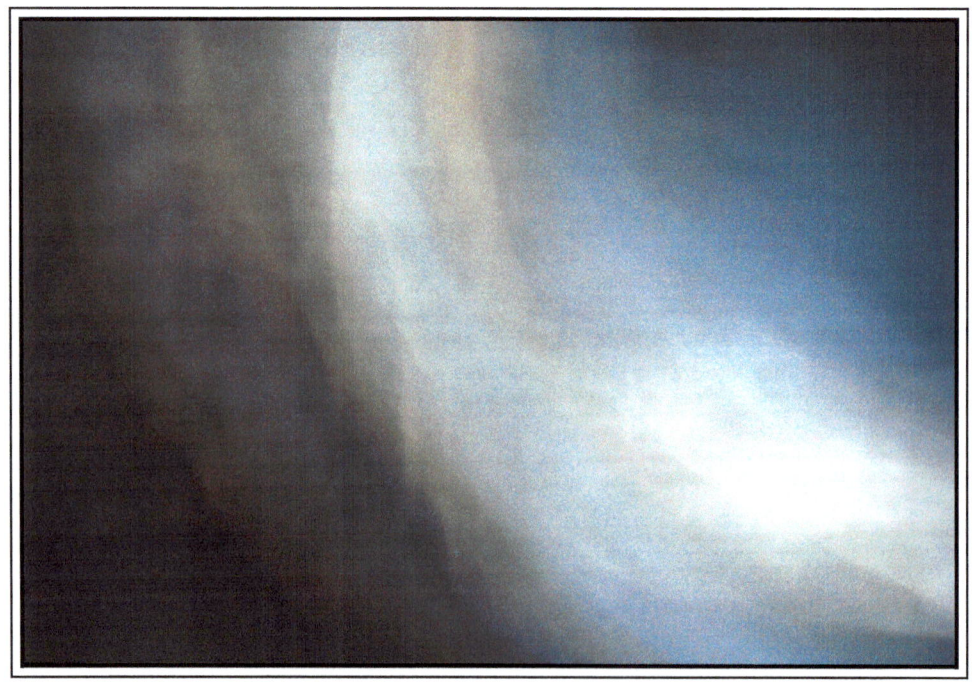

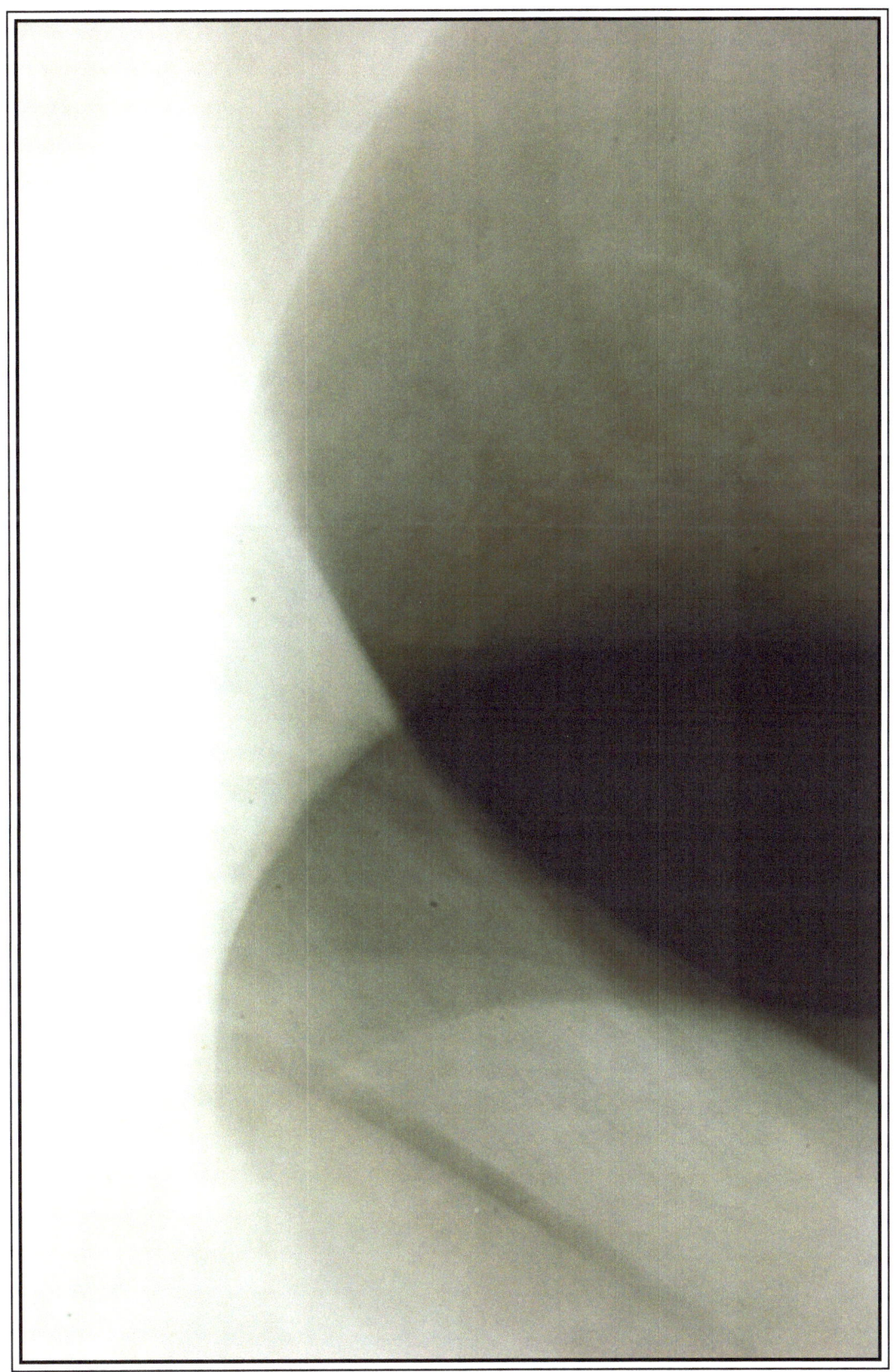

Tracks Abstracts

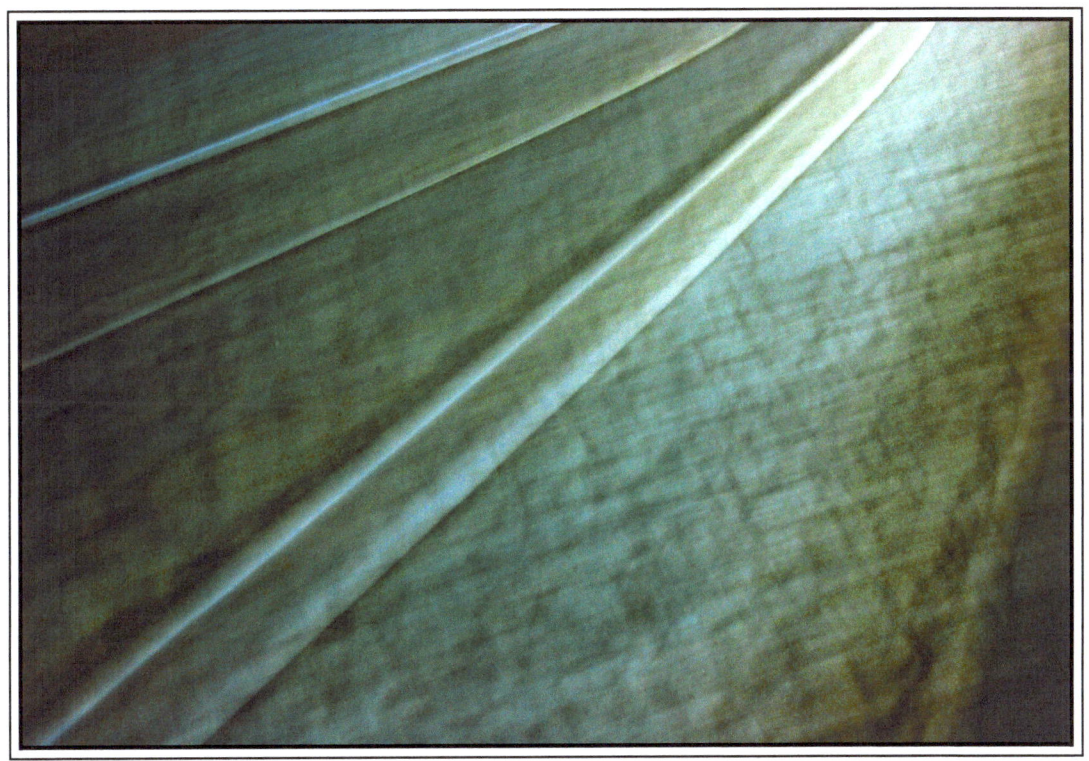

While visiting a southern city I came upon some old trolley tracks that were not being used anymore. The tracks were curved and the lights were reflecting off the edges in such a way that I saw something other than the "trolley Tracks". The flow of tracks, the lights and hint of the cobblestone street is revealed in the photographs. Somehow these tracks have life and movement. They are more than just tracks.

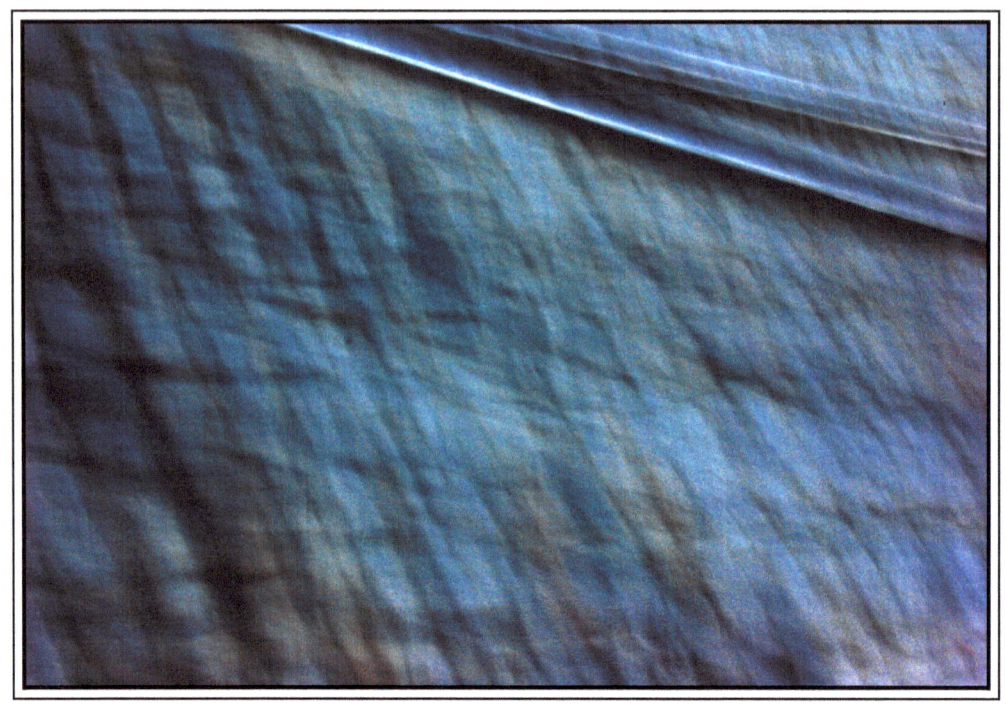

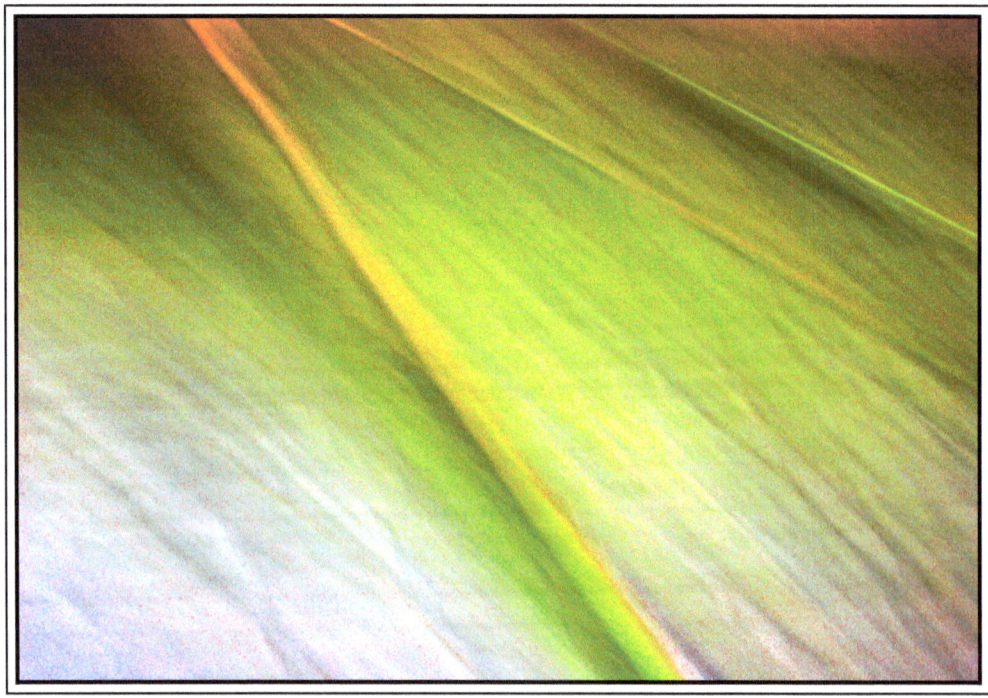

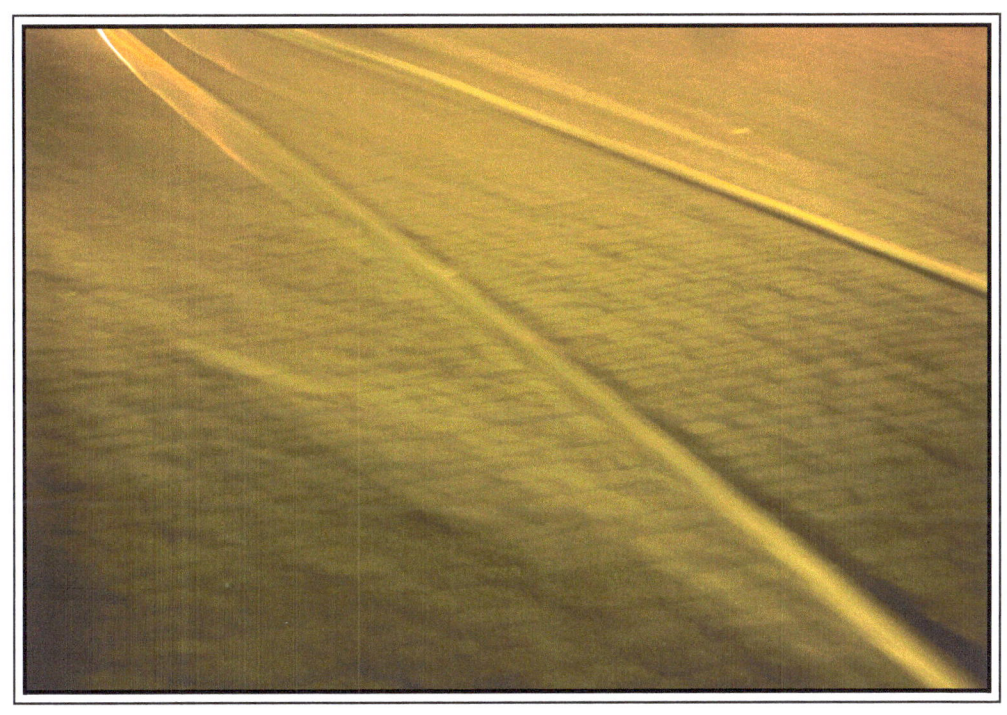

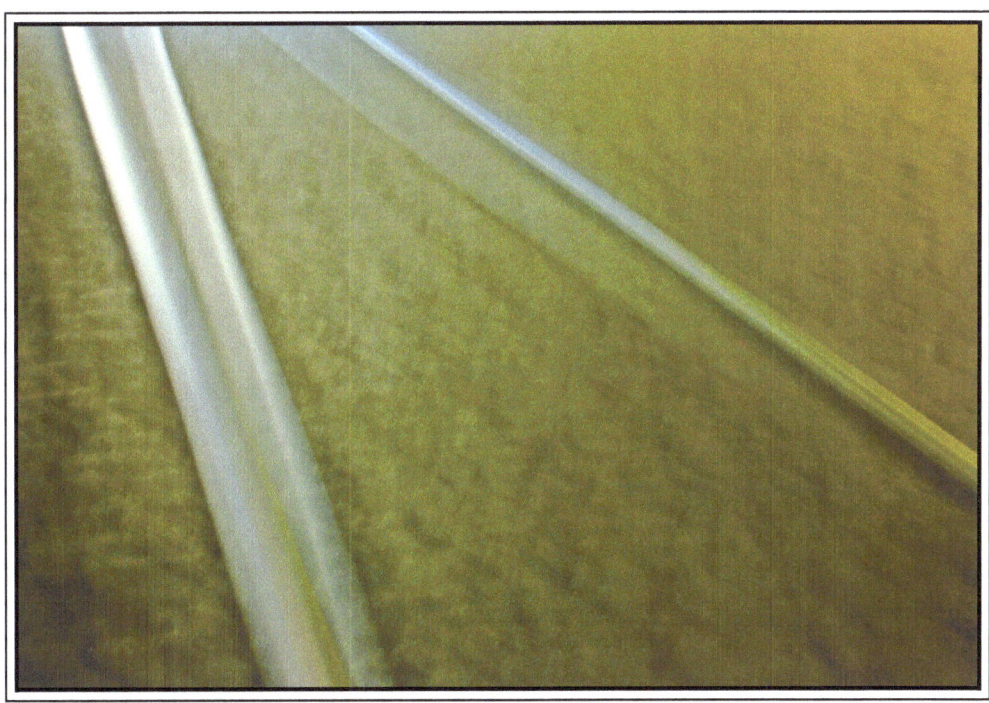

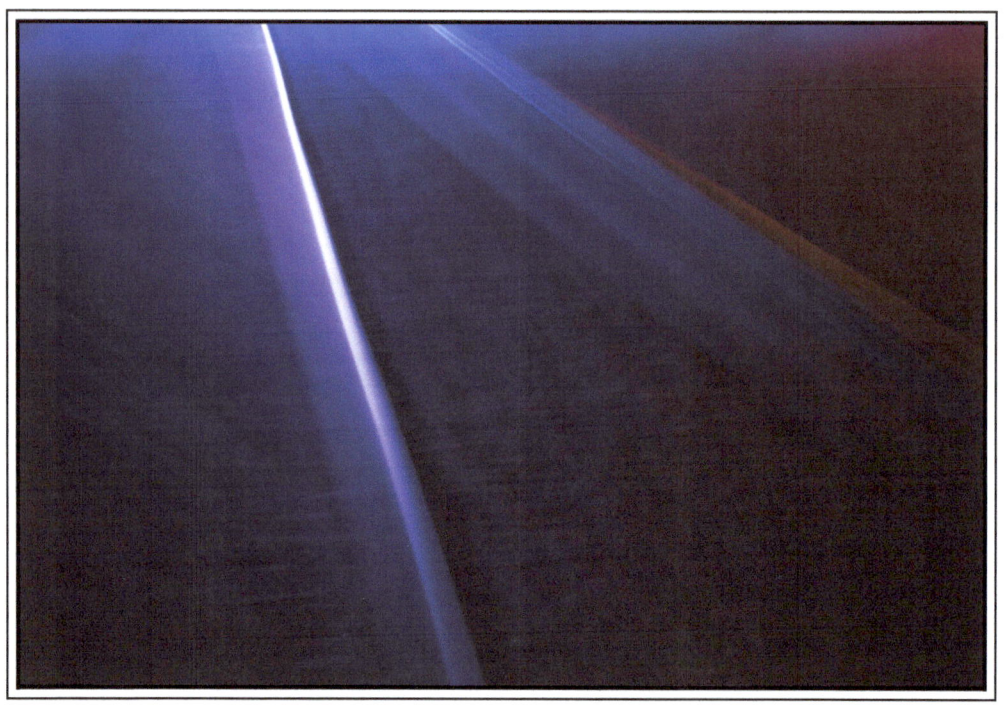

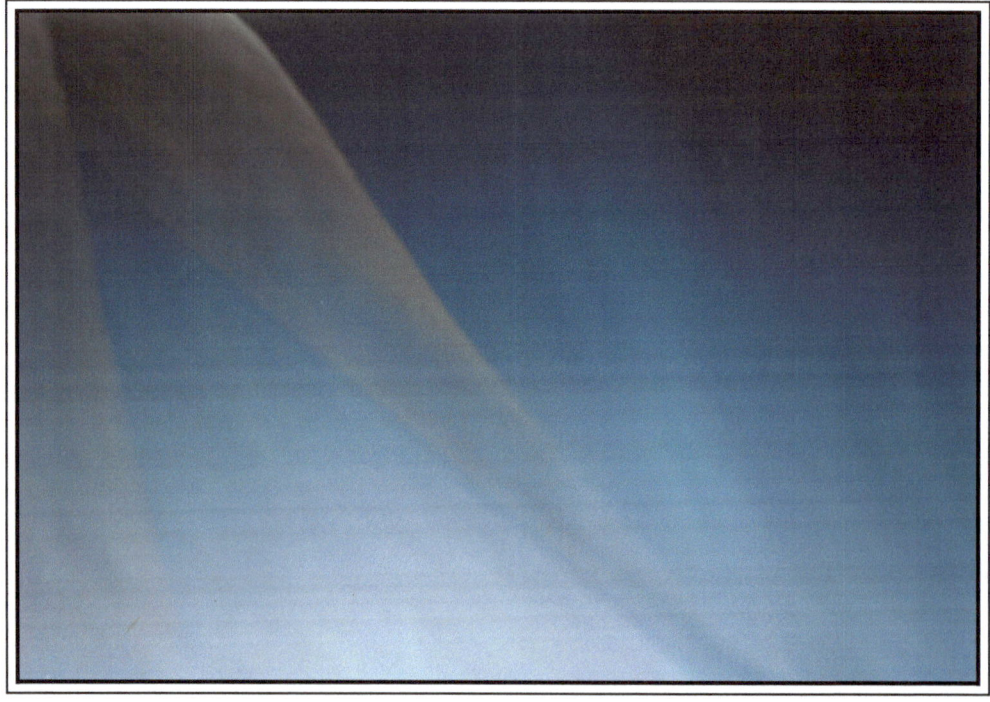

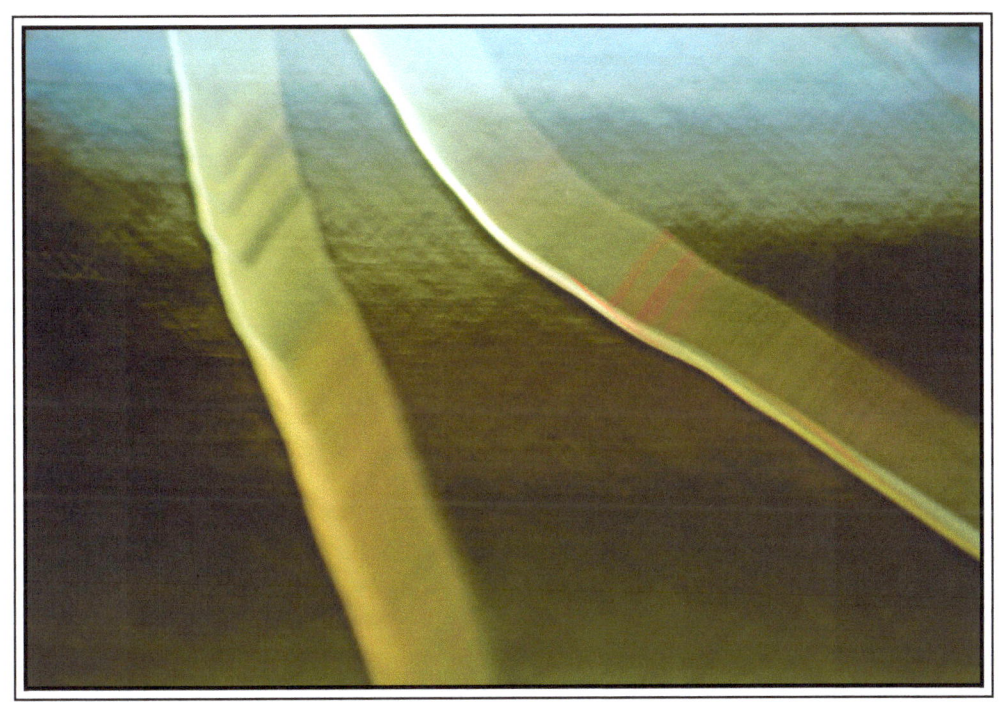

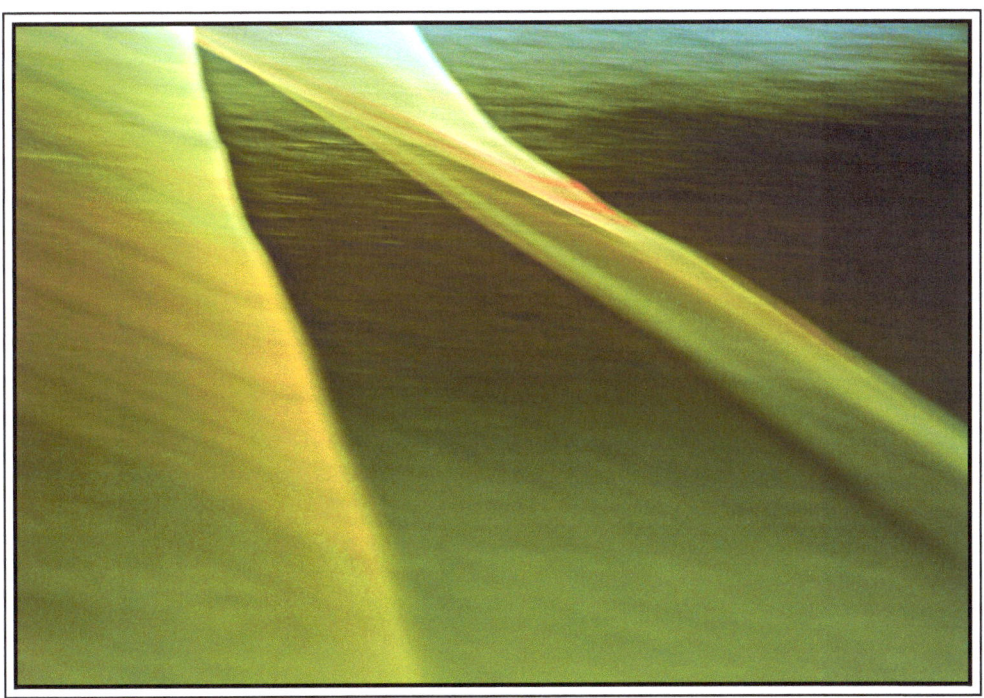

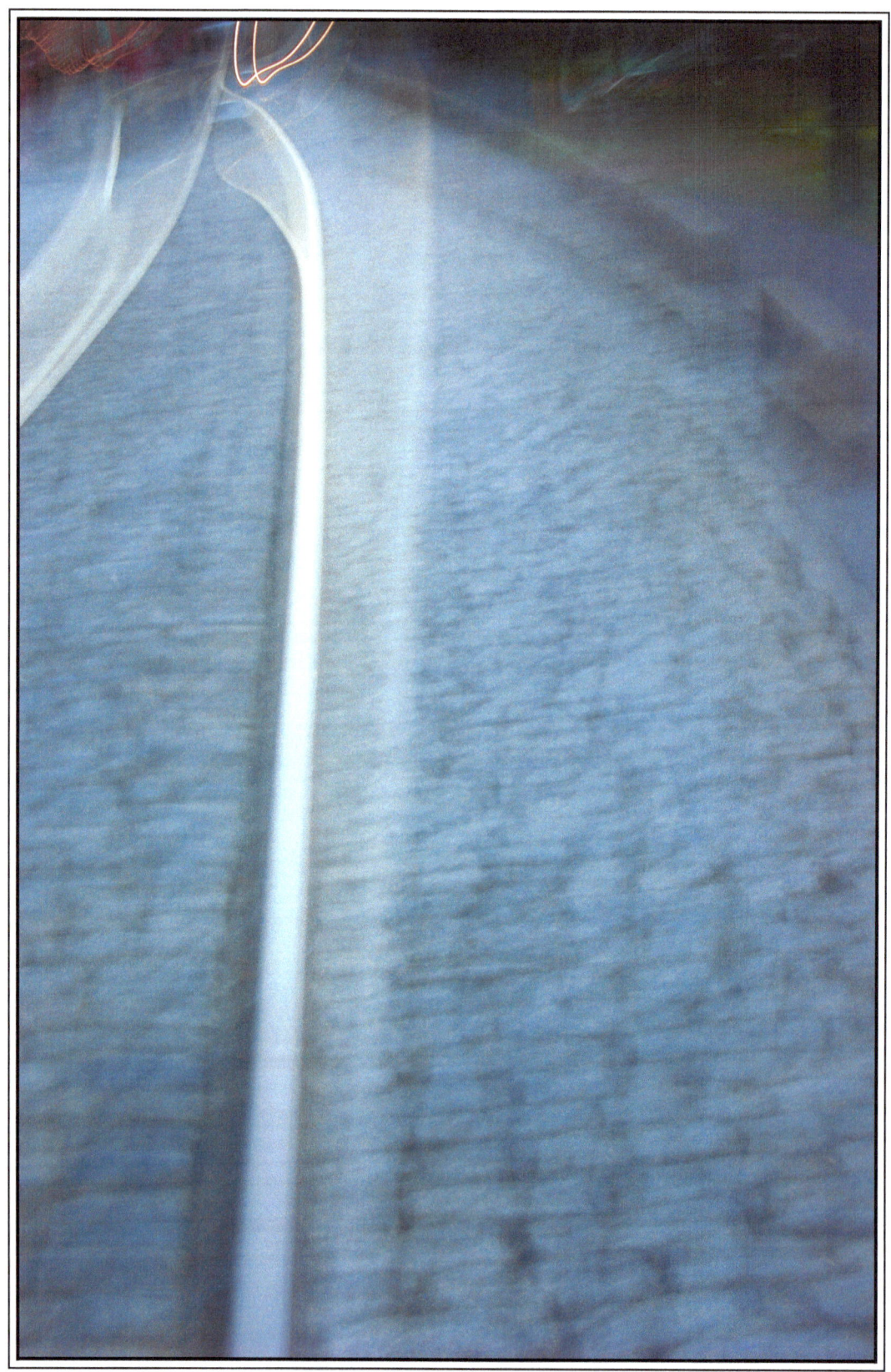

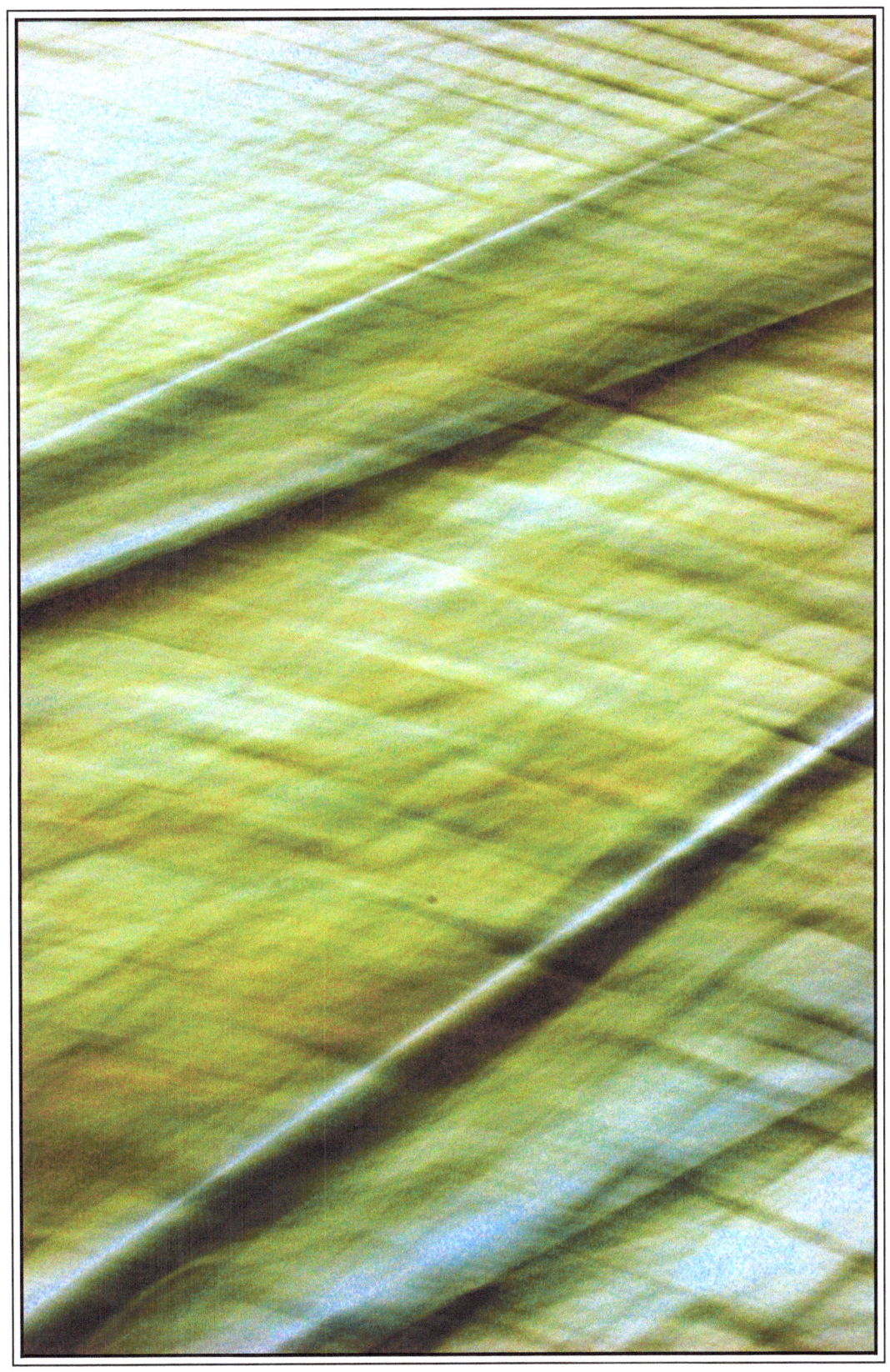

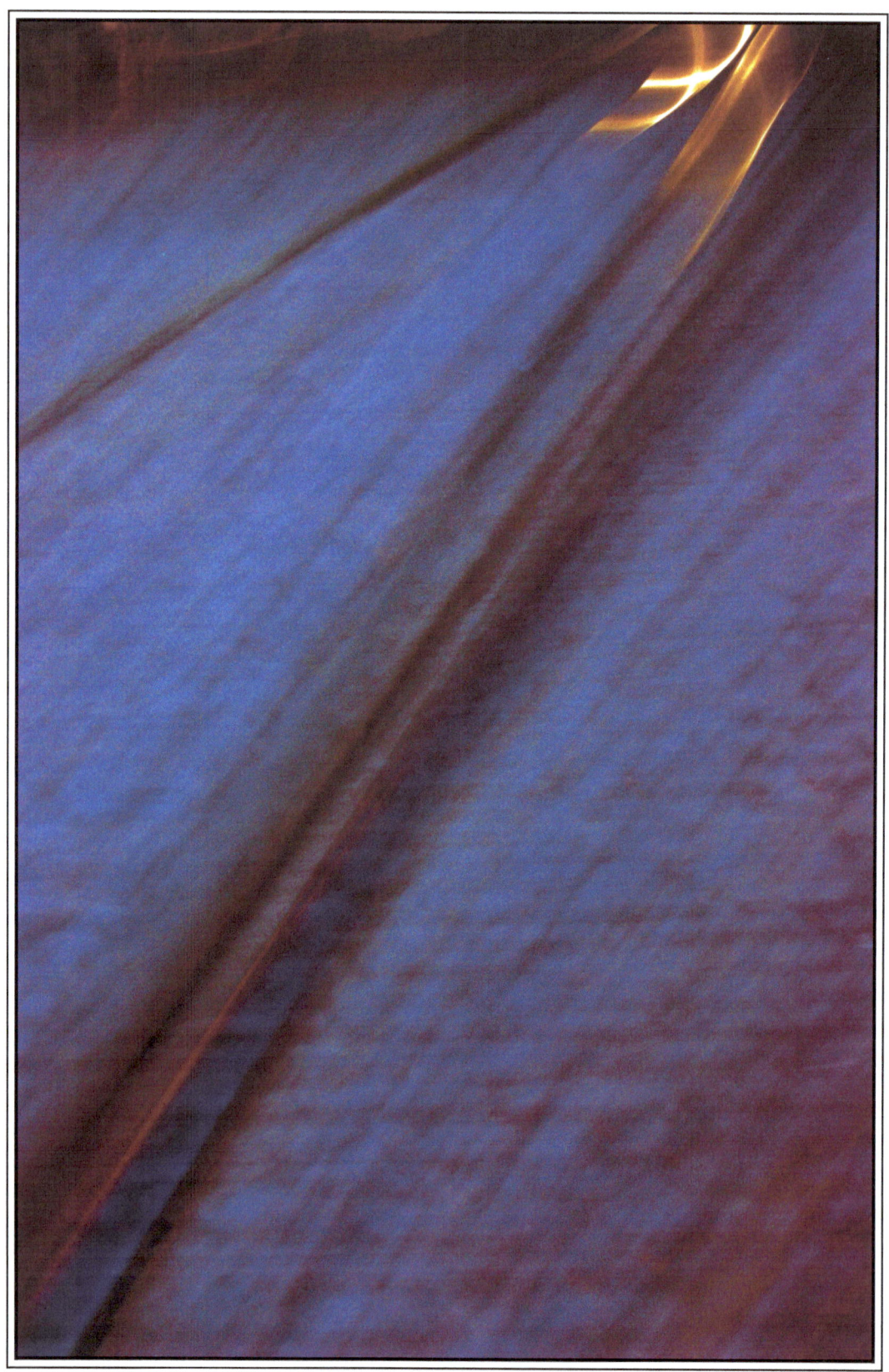

About the Author

John was introduced to photography and film through his Grandmother, with whom he lived. He has had a life-long love of photography and at one point studied to become a photographer. While serving as a "helper" to various photographers in New York City and Fort Lauderdale, he realized that the profession was very restrictive and that the "client's" ideas would always win.

John then embarked on a successful 35-year career in the real estate business. He now devotes most of his time to photography, taking the kinds of pictures that he feels inspired to take. Any money that is derived from his photography or related to photography is to be donated to various charities and worthy causes. At this point in his life, he has finally found in photography what he wanted to find so many years ago - that being the freedom to express his art in any way that inspires him and not to just the wishes of some "client".

His full, rich, awe-inspiring portfolio can be found on johnrmath.com photo.net and betterphoto.com Enjoy!

The End

www.ingramcontent.com/pod-product-compliance
Lightning Source LLC
Chambersburg PA
CBHW051050180526
45172CB00002B/587